Everything you always wanted to know about taking better photographs

Everything you always wanted to know about taking better photographs

Antony Zacharias

AMMONITE
PRESS

CONTENTS

Everything starts with...
Light!

Photography gives you the power to capture light. Your camera, quite simply, is a tool that turns light into an image. By doing so, it freezes everything in a magical moment in time. You are able to record what you see in a split second, and create a picture that lasts for ever. Anybody can do it. This book is about how you can do it better.

By learning a few rules and mastering some very simple techniques, you can start to bring art and creativity to your photography. Whether you are using a digital SLR, a mirrorless, a compact, or a phone camera, you will see how you can use it to craft more expressive images. Rather than just capturing everything you see, you can begin to make people see it in the way that you want them to.

Cameras have become increasingly complex tools, with so many buttons and menus. There is a temptation to select the "Automatic" mode so that the camera does your thinking for you. But it really is quite easy to take control. By doing so, you will release your camera's full potential and open up a new world of photography.

To begin with, we will give you a quickfire, graphic guide to the two key principles behind a successful photograph. The first is composition—which is about deciding what to include and what to leave out, and how you position everything within the frame. The second is exposure—which is about how you capture the light, through a combination of shutter speed, aperture, and ISO.

Once you have mastered these basics, that will be the end of the diagrams. Everything else will be demonstrated by looking at a variety of photographs, showing you how to put creative ideas into practice by explaining just why those photographs work so well. You will soon realize that you can do anything and everything with your camera, and that the only thing that limits your photography is your imagination.

Composition

Composition is the choice of what appears in the frame of your photograph (and what doesn't!), and how the key parts are positioned within that frame. When you see a subject that appeals to you, it is tempting to just "point and shoot" with your camera. But if you start to imagine your photograph as a painting within a frame, you will begin to think about how you can "compose" it.

There are some simple rules and techniques that can help you get to grips with good composition. If you start to think about objects within your images as shapes, about the space between them, and about the way they balance each other, you will have taken your first giant step toward taking better photographs.

Remember:
"Think of a photo as a painting in a frame"
(Learn everything you always wanted to know about composition from page 12)

CENTRAL COMPOSITION

Placing the most important part of your subject in the center of the frame is a safe approach to good composition.

RULE OF THIRDS

Divide your frame into three equal parts, vertically and horizontally, and place your subject where the lines intersect (see page 14).

LEADING LINES

Look for lines—such as a row of trees—and use them to lead the eye to the most interesting part of your image (see page 16).

GOLDEN RATIO

Picture a spiral in your image, where all points lead to the center, and you will imitate perfect compositions from the natural world.

Shutter speed

Shutter speed is the speed at which the shutter in your camera opens and closes. This controls the length of time in which light can reach the sensor, and so determines how light or dark your photograph will be.

- Shutter speed is usually measured as a fraction of a second. This might be shown in your camera as a single number or as a fraction (125 and 1/125 both indicate a shutter speed of 1/125 of a second).

- A slower (longer) shutter speed (such as 1/30 sec.) lets in more light. This is often necessary when your subject is dark. Slow shutter speeds will also blur moving objects.

- A faster (shorter) shutter speed (such as 1/500) lets in less light. This is often necessary when your subject is bright. Fast shutter speeds will also keep moving objects sharp.

Remember:

"Slow shutter speed, more light, more blur"

(Learn everything you always wanted to know about shutter speed on page 50)

CREATIVE SHUTTER SPEED

A slow shutter speed allows your subject more time to move in the frame, making it appear blurred.

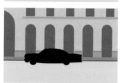

A fast shutter speed allows your subject less time to move in the frame, keeping it sharp.

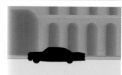

Using a slow shutter speed and following your subject with the camera (panning) keeps the subject sharp and blurs the background.

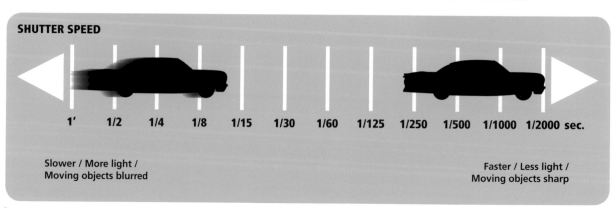

SHUTTER SPEED

1' 1/2 1/4 1/8 1/15 1/30 1/60 1/125 1/250 1/500 1/1000 1/2000 sec.

Slower / More light / Moving objects blurred

Faster / Less light / Moving objects sharp

Aperture

The "aperture" is the hole in the lens that light has to pass through to reach the camera's sensor. It controls how much light enters the camera, just as the size of a pipe controls how much water travels through it.

• The size of the aperture is measured in steps called f/stops. Each f/stop in the sequence doubles (or halves) the amount of light that can pass through it.

• A large aperture (such as f/2.8) lets in more light. This is represented by a *smaller* f/stop number because f/stops are actually fractions.

• A small aperture (such as f/22) lets in less light. This is represented by a *larger* f/stop number. Every time you reduce the aperture by one f/stop, you halve the amount of light that reaches the sensor.

Remember:
"Big hole, small number, more light"
(Learn everything you always wanted to know about aperture on page 44)

(Learn everything you always wanted to know about aperture on page 44)

CREATIVE APERTURE

A small aperture (f/22) creates a deep depth of field. This means a large area of your image will be in sharp focus.

A large aperture (f/2.8) creates a shallow depth of field. This means only a small area of your image will be in sharp focus. The rest will be blurred.

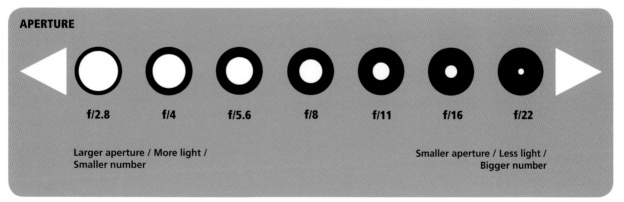

APERTURE

◄ ○ ○ ○ ○ ○ ○ ○ ►

f/2.8 f/4 f/5.6 f/8 f/11 f/16 f/22

Larger aperture / More light / Smaller number

Smaller aperture / Less light / Bigger number

ISO

The ISO setting on a camera determines how "sensitive" the sensor is to light, and therefore how much light is required to create a successful exposure.

- As the ISO number doubles, sensitivity increases by one stop.

- A low ISO setting (ISO 100) means the camera sensor is less sensitive to light. It requires more light to make a good exposure, but the quality of the image is high.

- A high ISO setting (ISO 6400) means the camera sensor is more sensitive to light. It requires less light to make a good exposure, but the quality of the image is lower. The image starts to suffer from a grainy texture called "noise", which reduces detail.

Remember:
"Low ISO, less sensitive, less noise"
(Learn everything you always wanted to know about ISO on page 58)

CREATIVE ISO

Shooting a dark subject at ISO 100 requires a slow shutter speed to let in enough light, which can cause camera shake and result in a blurred image.

Shooting at ISO 1600 means less light is required. It adds "noise" to the image, but a faster shutter speed can be used, keeping the image sharp.

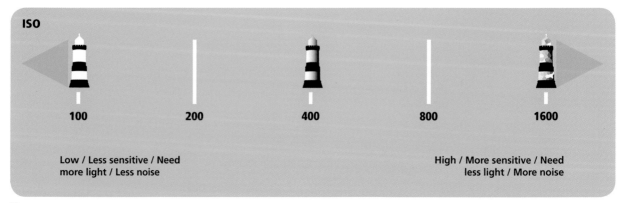

ISO

100 **200** **400** **800** **1600**

Low / Less sensitive / Need
more light / Less noise

High / More sensitive / Need
less light / More noise

Exposure

Exposure is the amount of light you use to create your image. It is what determines how bright or dark your photographs are. As you have seen, you control exposure by balancing the shutter speed, aperture, and ISO. Too much light can make your shot too bright, or "overexposed." Too little light can make your shot too dark, or "underexposed."

Remember:

"Shutter speed + aperture + ISO = exposure"

(Learn everything you always wanted to know about exposure from page 40)

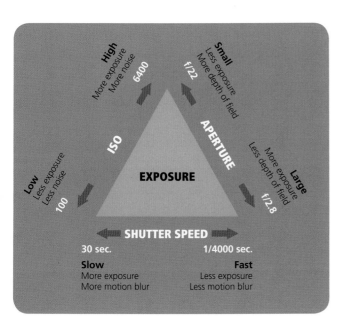

CREATIVE EXPOSURE

An underexposed image has more dark tones, which creates a more low-key, somber mood. Too much will cause shadow to turn black and lose detail.

An overexposed image has more bright tones, which creates a more high-key, light mood. Too much will cause highlights to turn white and lose detail.

EXPOSURE TRIANGLE

Adjusting shutter speed, aperture, or ISO means that the other two elements will need to change to maintain the same correct exposure. The exposure triangle helps you to see the related effects of the three elements. Look at the corners to see how changing one element requires compromise with another.

Everything you always wanted to know about composition

The rule of thirds
All good things come in threes

The "rule of thirds" is a term that is often thrown around by photographers, with some saying it's a hard and fast rule that will result in terrible photographs if you don't follow it. So what is it, why use it, and do you have to?

A lot of photographers struggle when it comes to composing a strong image, but this "rule" helps by indicating where you can position elements in the frame. It's simple to use and often leads to a more interesting shot, so if you are not sure how to frame a particular subject it's a great place to start.

The idea is that you divide your frame in three, both vertically and horizontally, by using imaginary lines that are equally spaced. Where you have vertical or horizontal features in your image, such as the horizon or a lone tree, try placing these on one of the lines and see how it leads your compositions. You will often find that it helps to create a more well-balanced and visually appealing photograph. You can also try placing individual elements (or the main subject) at any one of the points where the imaginary lines meet.

Although it is called a "rule," this is really just a guide, so don't feel you have to use it all the time. Sure, placing elements at the center of your frame can sometimes lead to a boring flat image, but sometimes it can create a strong and powerful image full of symmetry, so it's up to you to decide!

Why this photo works
STORMY SKIES

The power and beauty of the storm brewing in the sky behind the lighthouse was what I wanted to emphasize in this image. Placing the lighthouse on the imaginary left vertical "thirds" line gave plenty of space to show more of the storm. The horizon was also placed roughly on the lower horizontal "thirds" line to allow the sky to dominate.

Everything else you need to know
Balance & visual weight **20–21**
Angle of view **22–23**

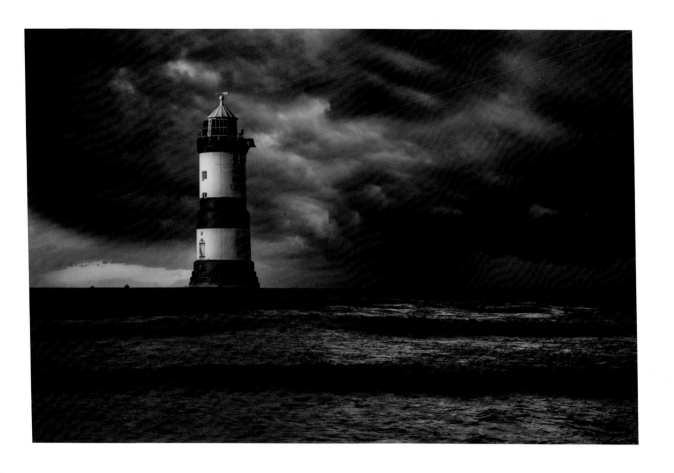

Leading lines
Drawing the viewer's gaze

Lines in a photograph are incredibly powerful and can be used in many different ways. One of their most important qualities is as "leading lines," which can draw your viewer's gaze toward different elements or areas, creating a sense of movement and direction. Your viewer will often not even realize that this is what is happening and they will subconsciously just follow the natural movement of the lines.

Different lines can influence your photographs in different ways. Curves and "S" shapes appear to meander around and send the viewer's eye on a gentle journey of discovery, while straight lines are more direct and move the eye faster. Horizontal lines—like a level horizon—represent calm and tranquility, while vertical lines imply strength and stability. Diagonal lines are the most dynamic of all and often provide the viewer with the greatest sense of energy and motion.

Lines can be obvious and graphic, but not always. Implied lines are also easily picked up by the brain. Although not as obvious as a physical line leading from "A" to "B" in a picture, the position of objects can create an invisible line to guide the eyes through points of interest. In portraits, the subject's eye-line is particularly influential, as it is human nature to make eye contact with people and to follow the direction of their gaze.

Playing with the perspective and camera angle can help accentuate lines and emphasize their position. So, think about where the lines in a scene are directing your eyes and try to use them to guide the viewer to the elements you want them to see.

Why this photo works
THE COURTHOUSE

This image of the entrance to a courthouse has lines working in multiple directions. The pathway nearest to the camera has strong diagonals, with the railings and concrete blocks leading toward the doorway at the center. The lines from the top of the image also lead down toward this center point. There are strong vertical lines in the form of pillars that are used to frame the sides of the image and these repeat themselves with implied lines receding into the distance. The more you look at this image, the more you will realize that your eyes are being led around the frame by lines.

Everything else you need to know
Framing **28–29**
Deep depth of field **48–49**

66 Lines can be obvious and graphic, but not always. Implied lines are also easily picked up by the brain. **99**

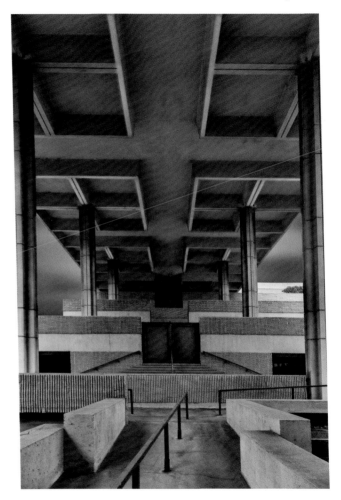

Foreground interest
Up close and personal

Although a photograph is a two-dimensional representation of what we see, a great way to really engage the viewer and produce a visually appealing image is to create a sense of depth. Try to visually divide up the area you are photographing into foreground, midground, and background. Think about what is going on in each of these sections and how they combine to create a more three-dimensional look.

A good starting place is to have some foreground interest at the front of the image. This provides the viewer with something to focus on initially, which will draw their gaze further into the scene. This doesn't have to be the main subject of the composition—it can be anything relevant to your shot, whether it's an interesting shape, structure, line, or object. However, it often works best if this is a point of interest just in front of the main subject of the photograph, so that it acts as a "step" that the viewer will use on the way to discovering what is going on further in the image. This will also help the viewer understand the relative distances between objects in a scene.

Don't forget that foreground interest is still subject to the normal rules of composition. It shouldn't just be placed front and center in the frame, but used creatively to add interest to the overall image.

Why this photo works
STORMY HARVEST

The impressive storm clouds and the contrast of the rays of sunlight that appear through them are the real focal point of this image. However, an image that was just of the sky would be lacking interest, so it was important to find a scene that would complement the drama above; in this case the harvested bales of hay, which add depth to the landscape. I framed the shot with one of the bales creating an initial close point of interest. The eye then follows the other bales through the field toward the horizon and sky. The bales also give a real sense of depth and show how the field rolls upward toward the horizon.

Everything else you need to know
Angle of view **22–23**
Scale & perspective **24–25**

❝A great way to really engage the viewer... is to create a sense of depth.❞

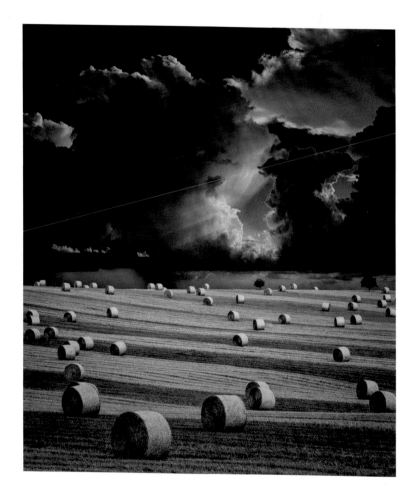

Balance & visual weight
Mastering the elements of visual harmony

Often, what we see can be very "busy" and our senses can easily be overloaded with everything in front of us that is competing for our attention. There is a temptation to try to capture all of this in a single photograph, but this usually leads to a cluttered and confused image; one that can be said to lack balance.

But what is "balance?" A balanced image is one where the elements are positioned to improve the viewing experience and everything just seems to sit in the right place. As we look at it, we find that our eyes are not flicking around uncontrollably or fixed on one specific point, but move nicely between all of the objects in the frame.

All the elements in a photograph have a different visual weight, with some appearing "heavier" than others. Bright colors, a large size, high contrast, dark tones, textures, and even groups of smaller objects will all have increased visual weight, which means they will naturally draw the viewer's attention more. Depending where it is placed in an image, a "heavy" element will often need something of equal weight (or multiple elements of a lesser visual weight) to balance the frame so the viewer isn't just drawn to a single point. This balance strengthens a composition and creates a sense of harmony between all of the separate parts in the image.

Why this photo works
EIFFEL TOWER AT SUNSET

The setting sun painted the iconic Eiffel Tower in Paris in a red hue. By deciding to only show part of the metalwork of the tower along one half of the frame, I was initially left with a mass of empty sky. Despite the nice gradation of color in the sky, the image looked unbalanced until a small cloud arrived. I waited for it to move into the empty space at the right and this dark shape provided enough visual weight to balance the strong heavy metal of the tower.

Everything else you need to know
Angle of view **22–23**
Scale & perspective **24–25**

**"All the elements
in a photograph have
a different visual weight,
with some appearing
'heavier' than others. "**

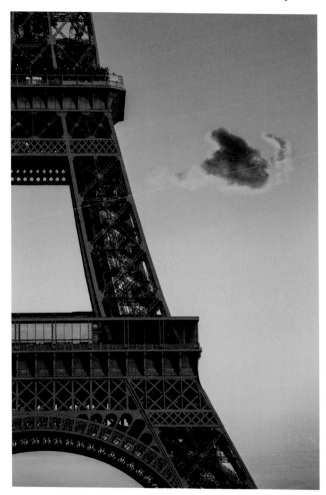

Angle of view
Changing your point of view

In our day-to-day lives we all view the world from eye level, and the most common thing for a photographer to do is to lift their camera up to their eye and take a picture. It doesn't matter if the subject is lower than us or higher than us, we raise the camera to our eye and point it down or up to take a shot.

The problem with taking photographs from a "normal" point of view is that it will often lead to predictable results: your viewers will have seen similar subjects from a similar position, and because your image appears obvious to them they won't necessarily be that engaged with it.

However, if you bend down, climb up, or twist and turn, you can often find a new and exciting angle of view, which will create images that are much more interesting to your audience. So the next time you see a photographer lying on the street or contorting themselves like a circus artist, remember that they will probably be seeing things from a different vantage point and trying to capture this. This may well result in something special—and I don't just mean dirty clothes!

Why this photo works
STRAIGHT UP

I came across this courtyard and opening between some buildings while walking through the back streets in a city. The light-blue walls and blue sky seemed to match perfectly. Although I had a wideangle lens with me, I couldn't quite fit enough of the scene into the frame for the composition I had in mind, so had no choice but to lie on my back in the street and point my camera directly up. The people walking around were giving me strange looks, but was it worth it? Well I think so!

Everything else you need to know
Scale & perspective **24–25**
Framing **28–29**

66 Taking photographs from a 'normal' point of view... will often lead to predictable results. 99

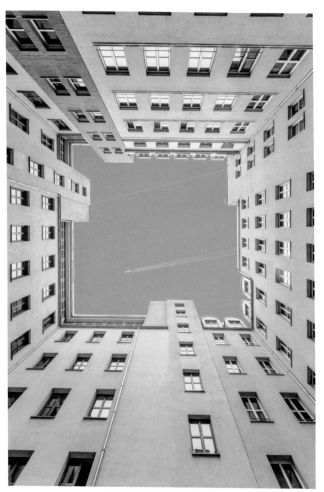

Scale & perspective
Everything looks small far away

Often it is almost impossible to tell the actual size of an object in a photo. Although our brain has the natural ability to understand what an object is—and therefore how big it usually should be—it also understands that distant objects appear small, even through they are full size. But this sometimes gets lost in a photograph. A macro lens can let you photograph tiny details on a scale that is way beyond what the eye can see clearly, for example, while vast landscapes can also be made to fit inside the borders of a small photograph. This means that it can be very hard to establish sizes, especially when you don't have anything in the frame to use as a reference.

It is often beneficial to try and show the true size of an object, or to at least give a sense of scale in the image, as it will help the viewer understand how the elements in a scene relate to one another. Giving a sense of what it is to actually be there can also help them engage more with your photographs.

There are a number of ways that you can help to emphasize these aspects in your images, including choosing a viewpoint that shows a range of distances or using a standard lens that doesn't distort the elements in a scene. Both of these things will help with the realism of what you are photographing and influence how your viewers see and relate to your image.

However, this may not always be what you want or need to do. You may find that you want to do the opposite, to create a more abstract image or one that deliberately removes any sense of scale or perspective.

Why this photo works
MAN IN RED

This interesting modern building is very large and I wanted viewers to appreciate the enormous circular frame that covers its facade. My initial shot didn't contain anything that revealed its true scale and I realized I had to add something to indicate its size. I returned a short time later and spotted a man sitting reading—his presence gave the image its much-needed sense of scale. Sometimes you just need to include a simple element to change the dynamic of your image.

Everything else you need to know
Angle of view **22–23**
Standard lenses **94–95**

66 It can be very hard to establish sizes, especially when you don't have anything in the frame to use as a reference. **99**

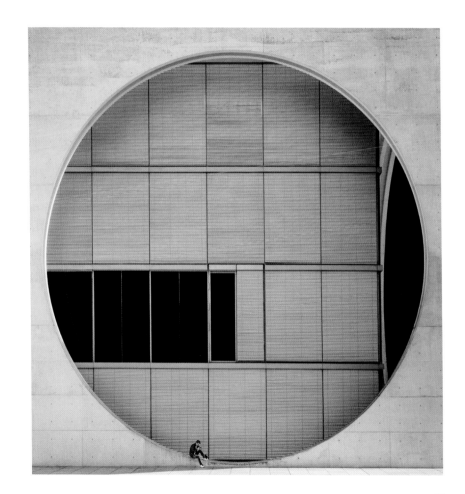

Finding patterns
Everything repeats

We all love looking at patterns and there is something about repeating forms that our brain naturally finds appealing. Patterns provide a form of "rhythm" or visual meditation and we have a strong reflex that quickly picks up a reoccurring theme.

The seemingly endless recurrence of something in your photographs, whether it's shape, lines, form, or color, will encourage a viewer to look at your images in a certain way. However, not all patterns have to be obvious or the main focus. Our minds can easily track and trace similarity across an image, so it depends on the scene you are shooting. Patterns can be slightly irregular, or limited to the background or to just part of an image, and still retain strong visual interest.

Patterns occur throughout nature in many forms and are often replicated in human design and construction, so look out for the same element occurring again and again and consider whether including it might improve your shot.

Another interesting way to use patterns is to allow the brain to settle on a recurring arrangement and then end it abruptly: a strong break in the harmony of a pattern can often help to create a really dynamic composition.

Why this photo works
FIRE ESCAPES

Fire escapes are a common sight throughout New York City, with the seemingly endless repeating patterns decorating the sides of many tall buildings. In this image, the direction of the light created a strong shadow on the side of the building, which added another layer to the repeating pattern. Cutting off the pattern at the top and bottom of the frame removes any definite ending; our mind will naturally assume that the pattern continues up and down the building.

Everything else you need to know
Filling the frame **30–31**
Telephoto lenses **92–93**

66 There is something about repeating forms that our brain naturally finds appealing. 99

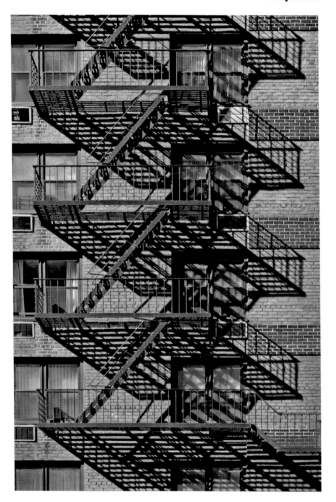

Framing
A picture within a picture

Every photograph has edges that limit what you reveal to the viewer, but you can amplify your subject by framing it within an inner frame or boundary in the scene. This could be done a number of different ways depending where you are, such as by using an open window or doorway, looking under a bridge, or peering through trees and shrubs—there are plenty of creative options here. Using an internal frame not only helps focus your viewer's attention on the subject, but it also creates depth by leading the viewer's eye through the scene.

You will find that when you use this technique your image will convey a real sense of purpose and stability. The internal frame will work in a similar way to a physical frame on a gallery wall; it sets virtual edges and stops the eye from wandering too far from the subject.

Consider the tonality of the frame and decide what works best for your composition. A darker frame will make it more obvious to your audience that their gaze is being drawn in a certain direction. A sharply focused frame will also be more obvious, so think about how you can use depth of field to make the frame completely sharp or slightly soft.

Why this photo works
WESTMINSTER

London has countless iconic landmarks that are photographed many times each day. Here, Elizabeth Clock Tower (home to Big Ben) at Westminster Palace is centered in the image to provide a sense of symmetry. The archway, with the remnants of the warm evening sun, frames the scene and also helps lead the eye toward the tower and the boat on the river. This gives a real sense of location and a greater feeling of depth.

Everything else you need to know
Leading lines **16–17**
Deep depth of field **48–49**

66 **Using an internal frame... creates depth in an image by leading the viewer through the scene,** 99

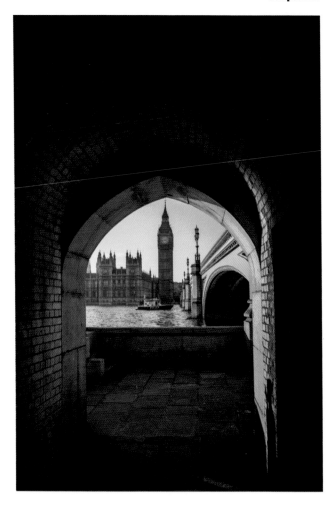

Filling the frame
Everything has its place

Once you decide on the main subject for a photograph you have to decide how to frame it. You have to compose the image so it is not only interesting for the viewer to look at, but so that it is also clear what the focal point is. Sometimes this is obvious, but if there is a multitude of objects you may need to work slightly harder.

Depending on the subject, you have to decide whether it is important to show its relationship to its surroundings. Does it help the viewer if they can see more of the environment where you took the image, putting your subject in context, or can you fill the frame with the subject instead? By removing any external information from the scene you will direct focus solely onto your chosen subject. This is a useful technique when the wider setting is boring or distracting, or just doesn't add anything overall.

Move around and especially move closer: the idea here is to make your subject dominate the frame. However, you don't want your shot to feel too confused or overcrowded, so sometimes you may want to leave a little bit of space around the edges. At other times you may prefer to zoom in and create a much tighter crop, as shown opposite.

Filling the frame with your subject also changes the way that it is portrayed. Making it a dominant part of the frame will make it more imposing, which can be a useful way to intensify the visual presence of something large or important and increase the impact of your shot.

Why this photo works
ZEBRA

This resting zebra creates a striking image that naturally needed to be in black and white. Rather than try to photograph all of the animal, I decided to zoom in close and capture just a part of it to emphasize the beauty of the patterns and strong light on its head and neck. Filling the majority of the frame with the zebra ensures there is no question what the subject of the photograph is. It also helps to accentuate the patterns on the animal, which may have perhaps been less prominent if I had tried to include all of it in the frame.

Everything else you need to know
Telephoto lenses **92–93**
Telling your story **106–107**

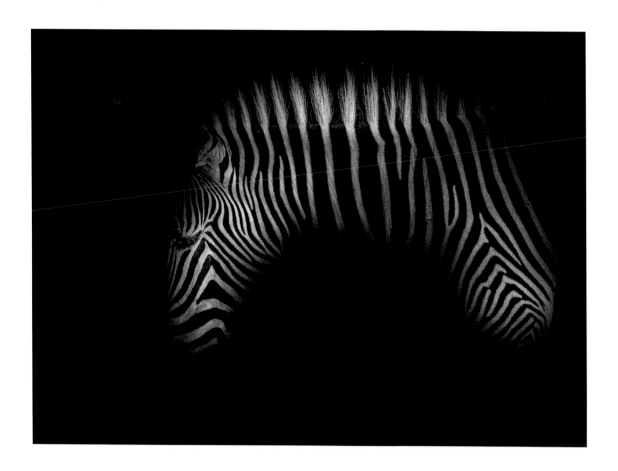

Making it minimal
Where did everything go?

When we talk about minimalism the expression "less is more" springs to mind. In relation to photography, minimalism is about stripping back and simplifying your composition so that it only includes the essential elements. This can be a little harder than you may initially think, as the fundamentals still need to be applied, such as control of focus, exposure, light, composition, and strong subject matter.

Minimalist compositions position the subject away from any other distracting elements, which can be a fantastic way to catch the viewer's full attention. However, having fewer elements in a photograph means that the ones that are there really need to have impact, so look for something strong and compelling.

You also need to remember that, while having extra space around your subject can strengthen a composition, you still need a sense of balance to ensure that the image works. So, think about how you position the elements in the composition, how they sit together, and the relationships between them.

Why this photo works
TRIANGLE

I noticed the interesting shadows being cast by the bright light coming through a window and positioned a pencil on my desk. I played with its angle so the shadows created different patterns and eventually arrived at this triangular shape; I like the color contrasts and the way that the sharp lines of the pencil interact with the soft shadows. Sometimes unique images can be made by seeing what is right there in front of you: you don't always have to travel far to take interesting photographs.

Everything else you need to know
Balance & visual weight **20–21**
Thinking in color **36–37**

66 Minimalist compositions... can be a fantastic way to catch the viewer's full attention. 99

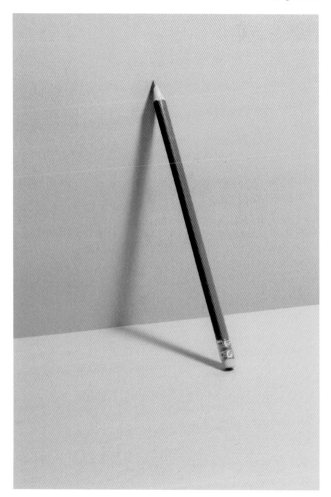

Abstraction

What you see is not always what you get

You don't always have to capture a clear and obvious photograph of the scene in front of you. Abstract photographs are those where what you see isn't readily identifiable and is not necessarily what your eyes would see.

This may sound a little confusing at first, as instinct is often to show clear, well-defined subjects in your images. There really are no real rules for abstract photography, though. You can decide how much to reveal and how easy it is for your viewer to figure out just what it is they are looking at. The basic step is to move away from merely documenting what is in front of you in "true-to-life" form, and strip your subject down to more simple forms and shapes. You might achieve this by showing a small part of something, using blur, using strong shadows and light to reveal a graphic form, or simply by placing the emphasis on color. Experimentation is the key.

Abstract images often take extra time and thought from the viewer to discover what they are showing. The mind feels a strong sense of satisfaction when it figures out what it is looking at, so your audience will enjoy the challenge in such a photograph.

Why this photo works
OCEAN COLORS

An early morning stroll along the beach provided a beautiful combination of peace and tranquility, and stunning changing light. As the waves rolled out they kept revealing golden sunlight on the clear sands, along with the blue tones of the ocean. This combination of colors and the hints of the warm sunrise were mesmerizing, so I decided to create an abstract image that emphasized the movement of the water and the variation of colors. Choosing a slow shutter speed and moving the camera in time with the rolling waves added a little blur and softness to the water, as well as removing any real detail in the ocean or the beach. This created a more painterly feel to the image and a more abstract representation of the scene.

Everything else you need to know
Blurring motion **54–55**
Creativity **102–103**

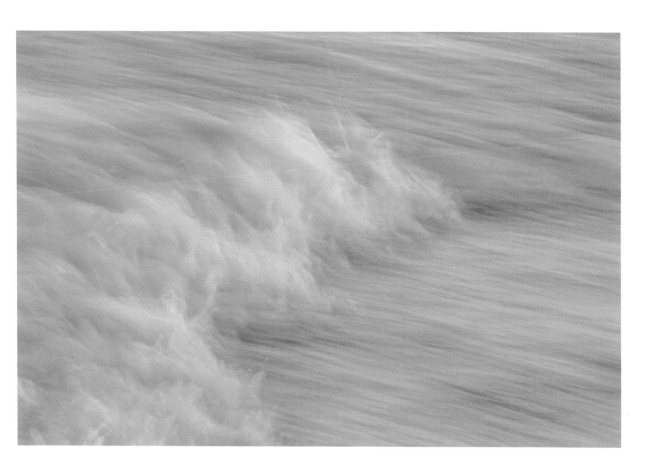

Thinking in color
See red and feel blue

How you capture and use color can have a big influence on your photographs, and by using strong color relationships you can create much more powerful images. You can achieve this by controlling the actual color itself (hue), its brightness (luminance), and its saturation (intensity). Different colors will sit together better than others, and playing with all of these factors can help you produce more creative and appealing images.

Think about how including color helps your viewers interpret a scene, or whether the chaos of color adds confusion. Vivid colors will have greater weight in an image, drawing more attention than muted hues, which needs to be considered if this is not the area you want your viewer to be drawn to. Colors can also be used to help separate different shapes and objects, so they can assist your viewer when it comes to appreciating and understanding a scene.

Different hues also trigger different emotional responses. We associate yellow and orange with warmth and sunshine, while blue tones feel much colder. Red hues suggest energy or danger, whereas green is more positive and implies nature and plants. The intensity of these colors will also play a role in how someone looks at your images—a scene full of bright colors is more likely to be associated with happiness and joy than a similar scene comprised of dull, muted tones.

Why this photo works
RAINBOW TULIP

This image places all its emphasis on the vibrant colors of a flower and the blur of color from others in the background. Shooting close up has made it become an abstract image, which focuses the viewer's attention on the intensity of the various hues, rather than providing an obvious representation of a tulip. The use of color in this way makes for a strong, dynamic, and happy image.

Everything else you need to know
Balance & visual weight **20–21**
Macro lenses **96–97**

66 How you capture and use color can have a big influence on your photographs. 99

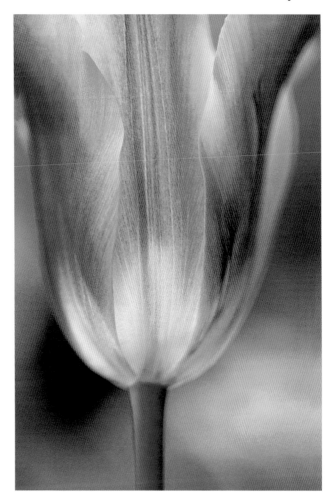

Black & white
Thinking in shades of gray

Although color photography represents reality, images in black and white have a huge visual appeal. Removing color can strip back the chaos of competing hues and help you highlight all the elements of a composition in a more straightforward way.

The first decision that has to be made is when, or if, you should convert an image to black and white. How do you decide? Well, not all color images will work well in monochrome, as black-and-white images have slightly different requirements to their color cousins. To start with, a strong monochrome photograph needs a good contrast range to work well. This means the different tones—shades of gray—between the darkest shadows and the brightest highlights, which will help to emphasize shape, texture, and form. In a black-and-white photograph, the gradients between light and shade are arguably more powerful than they are in a color shot.

When it comes to shooting in black and white, consider recording Raw and JPEG files simultaneously, with the JPEG set to your camera's monochrome mode. This will give you a monochrome JPEG that you can immediately review—which will show you whether a black-and-white image works or not—as well as a high-quality (color) Raw file that you can convert to black and white in postproduction on your computer. Converting your shots in this way will give you much more control over the process and ensure that you emphasize the tones you want to.

Why this photo works
ANHINGA

I chose to convert this portrait of an anhinga in the Florida Everglades to black and white to make a more dynamic image. The monochrome treatment simplified the scene and removed the distraction of a colorful background that drew attention away from the main subject. This also placed more emphasis on the contrasting patterned feathers and other elements of the bird itself. The strong range of tones, together with the position of its outstretched wings, helps make a strong punchy image where the beauty of the bird really dominates the frame.

Everything else you need to know
Finding patterns **26–27**
Making it minimal **32–33**

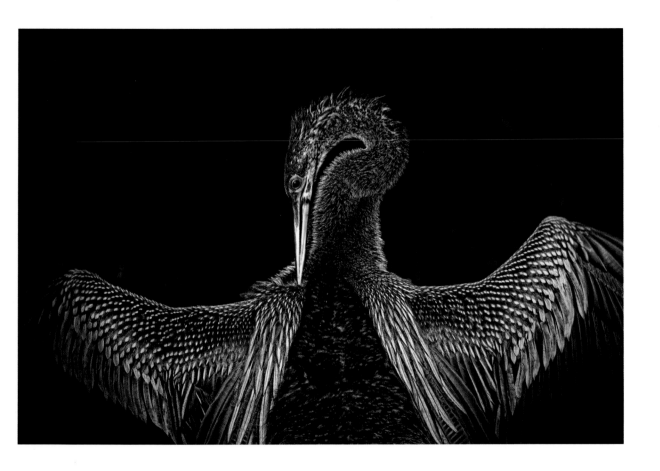

Everything you always wanted to know about exposure

Camera modes
"A" is for "avoid"

Your camera has a lot of exposure modes to choose from, so just where do you start? Although you might think that Automatic (Auto) mode and the other "creative" modes (such as landscape, portrait, and so on) are helpful, all they actually do is let the camera decide everything for you. Your camera doesn't know where you are or what you are photographing, and most important of all, it doesn't know what you want your image to look like! So the first thing is *not* to use Auto. But what should you choose instead?

Program (**P**) mode is similar to Auto, as it lets the camera choose the initial exposure settings for you. However, unlike Auto you are free to change them. This can help when you are starting out and you're not sure what settings to use.

Aperture Priority (**A** or **Av**) mode lets you select the aperture (and ISO) you want to use and the camera will set the shutter speed needed for the correct exposure. Use this mode when your priority is controlling the depth of field in your image.

Shutter Priority (**S** or **Tv**, for Time Value) mode lets you set the shutter speed (and ISO) you want to use and the camera will calculate the necessary aperture setting. This is the option to choose when the timing is important and you either want to freeze the motion in front of you or to blur it.

Manual (**M**) mode gives you complete control over the aperture, shutter speed, and ISO settings. You choose the settings and the camera will not override any of them, even if the image is going to be over- or underexposed.

Why this photo works
SATELLITE STAR TRAILS

This image of radio telescopes captures the stars rotating around the North Star at the center of the sky. The final image is made up of about 300 exposures, each of which captured a small amount of the movement of the stars; combined in postproduction they show the full movement. To make each exposure I chose Manual mode to keep the settings consistent and set a shutter speed of 25 sec., a wide aperture of f/2.8, and a high ISO (1600) to increase the camera's sensitivity to the light.

Everything else you need to know
Aperture **44–45**
Shutter speed **50–51**

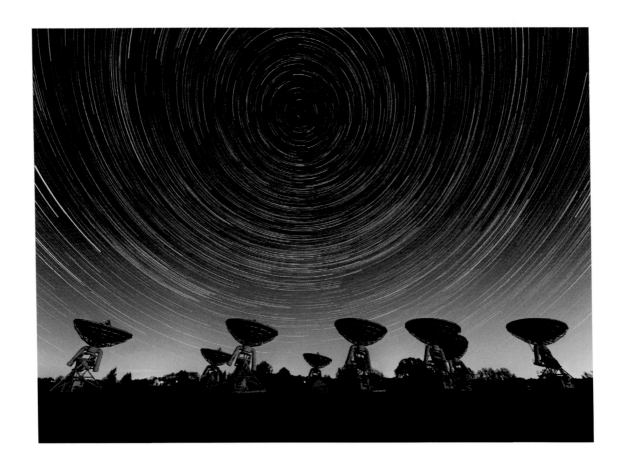

Aperture
Letting the light in

The aperture is the opening in the lens that controls the amount of light entering the camera. When you need to let more light into the camera to brighten your exposure you can open up the aperture, and when you want less light you can close it down. Think of it like your eyes. Your pupils contract in bright sunshine to reduce the amount of light, and in darkness your pupils open wider to help you see more clearly. A camera's aperture is the same.

The aperture setting is measured in f/stops, as outlined on page 9. You can use either Manual (**M**) mode or Aperture Priority (**A** or **Av**) mode to determine how wide or narrow the aperture will be. If you choose Aperture Priority, the camera will automatically calculate the shutter speed that is needed to obtain a good exposure.

As well as determining how much light is allowed to pass through the lens, the aperture also controls how much of the scene will appear in focus. This is called "depth of field" and is essentially a "zone" of sharpness that extends in front of and behind the focus point. The next few pages will reveal more, but for now you just need to remember this:

Larger aperture = Smaller f/stop number = Lets more light in

Smaller aperture = Larger f/stop number = Lets less light in

Why this photo works
COOKIES

As nothing was moving here, I decided to use Aperture Priority mode when taking this image. I selected a mid-range aperture of f/5.6 to ensure that the camera could capture enough light. I didn't need to worry too much about depth of field as all the cookies were at a similar distance, facing the camera.

Everything else you need to know
Shutter speed **50–51**
ISO **58–59**

66 The aperture also controls how much of the scene will be in focus. 99

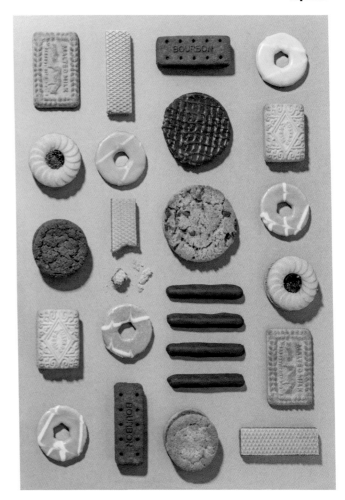

Shallow depth of field
The wonders of blurred vision

A shallow depth of field refers to how sharpness falls away in an image. When a photograph is taken with a wide aperture (a small f/stop such as f/2.8 or f/4, for example), the point you focus on will be in sharp focus, but the scene in front of and behind it quickly falls off into blur. The amount of blur, and the extent of it, depends on the aperture you choose.

We are not used to selective focus in our daily lives. Our eyes will always focus where we look and our brain will try to retain sharpness in areas that we are not precisely focusing on. A shallow depth of field therefore enables you to create something that is naturally "new" and intriguing.

Using a wide aperture and shallow depth of field also lets you isolate a subject by blurring the background (and foreground). This creates a separation between the subject and its surroundings and makes them stand out. Portraits are often taken in this way to remove unwanted distractions and details that might otherwise distract the viewer from the subject.

Watch out, though. Depending on the chosen aperture, the depth of field can often be very small and the out-of-focus areas can fall away fast. This means you need to take extra care to ensure you nail your focus: for photographs of people, the eyes should always be sharp.

Why this photo works
THE REAL COWBOY

In this image, the cowboy is clearly the main subject. I wanted to include a sense of the environment where this shot was taken, but the town in the background was complex and distracting and I wanted the viewer's attention to be focused on the cowboy. I decided to simplify the detail behind him by choosing a wide aperture (f/2.8) and focusing on his eyes. This ensured that he was in sharp focus, while the focus fall-off separated him from the busy background. You can still see the suggestion of a house and trees behind him, but the shallow depth of field has meant that none of these details are sharp and there is a clear separation between the subject and the background.

Everything else you need to know
Aperture **44–45**
Focus **120–121**

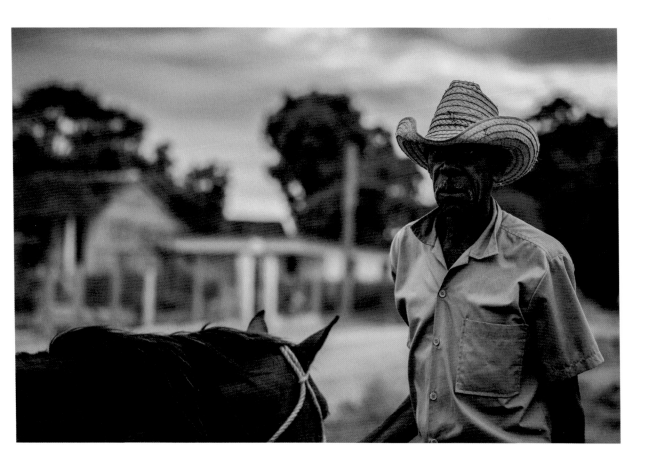

Deep depth of field
Everything can get deeper

A deep depth of field is where a large part of a scene appears in focus, from the foreground way off into the distance. Certain scenes can be more appealing when you can see all the detail, as it can help the viewer relate to the scene, showing them what they would see if they were actually standing there at the time the photograph was taken. This is especially true with landscape photographs, which are often taken with a deep depth of field. Here, the shutter speed and capturing motion are not as important as ensuring that everything is in focus.

To achieve a deep depth of field you need to use a small aperture, which is confusingly represented by a large f/stop number, such as f/16 or f/22 (because the number is actually a fraction). Using a small aperture will limit the amount of light that can enter the camera. This means that shutter speeds will tend to be slower, and a tripod (or higher ISO) may be required to compensate and ensure that a sharp image is captured.

Why this photo works
STOCKHOLM OLD TOWN

In this image of Stockholm, Sweden, I wanted to capture the mood of the cobbled streets in the "old town." The bicycle and flower box were interesting elements in the foreground of the scene, but I was also intrigued by the Gothic-style church in the distance. Using Aperture Priority mode I selected a small aperture (f/16) to ensure all the elements remained in focus throughout the image. As I didn't have my tripod with me I selected a high ISO to increase the shutter speed and avoid camera shake.

Everything else you need to know
Camera modes **42–43**
ISO **58–59**

66 Certain scenes can be more appealing when you can see all the detail. 99

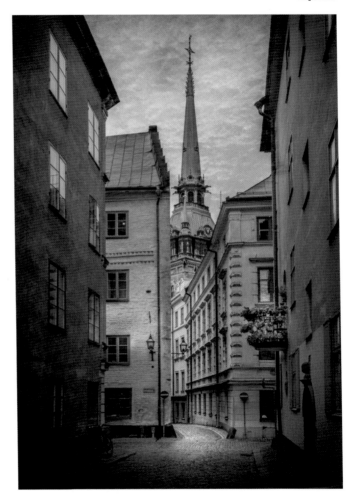

Shutter speed
The importance of knowing your speed

The shutter is a gateway for light to reach the camera's sensor. You can control how long it stays open by setting the shutter speed, which determines how much light the sensor receives and how bright or dark the image will be. You will generally want to use a slower (longer) shutter speed when it is darker, as this will let more light in and avoid an underexposed image, but if it is very bright a faster shutter speed will be needed to avoid overexposure.

To control the shutter speed you can use either Manual (**M**) mode or Shutter Priority (**S** or **Tv**, for Time Value). The advantage of Shutter Priority mode is that you set the shutter speed and the camera will automatically calculate the aperture that is needed to obtain a good exposure at your chosen setting.

Care should be taken when using slow shutter speeds, though, as you may not be able to handhold the camera without introducing camera shake. Use a tripod or put your camera on a stable surface to prevent this.

Your chosen shutter speed will also affect how your subject is captured, and—as you will see over the next few pages—can be used creatively to control the look of your shot.

Why this photo works
NIGHT TRAILS

There wasn't much available light for this image, as the sun had already set on the Tower of London, so I knew I would need a long shutter speed to expose this scene correctly. I also saw that there were a lot of boats sailing past on the River Thames, and I wanted to capture their lights as streaks through the image—another good reason for a long exposure. I set a long shutter speed in Shutter Priority mode, as the aperture was not overly important to me here and I was happy for the camera to choose the setting.

Everything else you need to know
Aperture **44–45**
ISO **58–59**

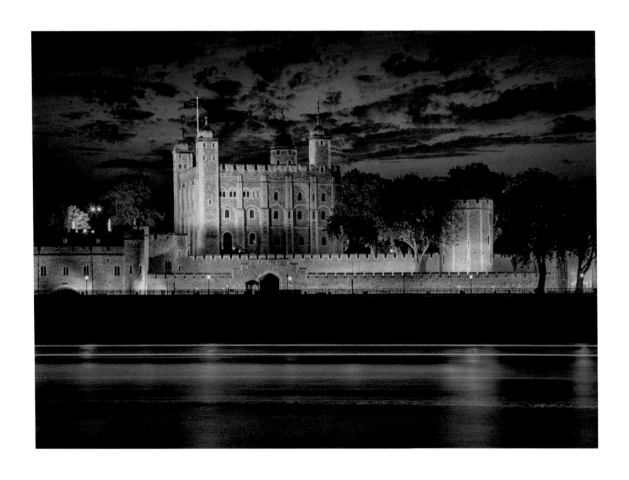

Freezing motion
Shooting fast to slow things down

A fast shutter speed will freeze motion, so it's ideal for stopping a moving subject in its tracks. You have a choice whether you want to capture a mere millisecond of time or a fraction of a second longer, and the speed you use will have a direct impact on what you capture and what the photograph looks like.

Generally, when your subject is moving around you will want to use a fast shutter speed to freeze the motion, or to avoid any camera shake if you are handholding your camera. It is important to remember that in either case a fast shutter speed will limit the amount of light reaching the sensor, and if it is set too fast you may end up with an underexposed image. You may find that you have to open up the aperture, increase the ISO, or use an external light source to provide more light.

Why this photo works
RAINBOW SPLASHES

Using an extremely fast shutter speed opens up a whole new creative world by capturing movement that is so fast it is generally invisible to the human eye. This can give your viewers the opportunity to see things clearly that they wouldn't normally get to see. In this image, the splashing liquids were moving at a very fast speed, but I was able to freeze the motion by using a fast shutter speed together with a flash.

Everything else you need to know
Camera modes **42–43**
ISO **58–59**

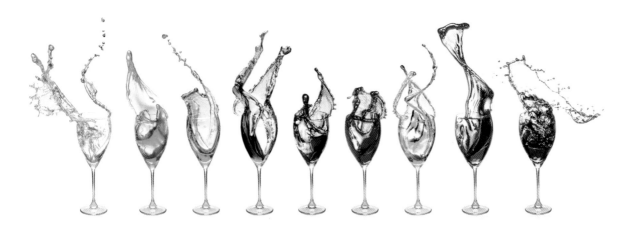

Blurring motion
Shooting slow to capture more

When there is less available light—on a cloudy day, at night, or in a darker room, for example—a slow shutter speed can be used to build up the exposure and make your image brighter. It is unlikely you will be able to hold the camera steady during a long exposure like this, so use a tripod or other stable surface.

A slow shutter speed can also be used creatively. If the camera remains still, anything that moves through the frame while the shutter is open will be recorded as a blur. The slower the movement, the more pronounced the blur will be, while only a faint blur will be captured if the movement is extremely fast. This blurring technique can produce interesting results and add a real sense of speed and movement to an image.

Another technique using longer shutter speeds and blur is to deliberately move the camera while taking a long-exposure shot. Known as "Intentional Camera Movement" (or ICM), this will cause everything in the composition to blur. Depending on how much movement there is, the direction of the movement, the subject, and the exposure time, this can lead to some really creative abstract images. Bear in mind that if the shutter speed is too long you risk letting in too much light and overexposing the image.

Why this photo works
THE DANCER

This image captured the blurred movement of a dancer, as she danced across the studio in front of the camera. Her movement was caught as a blur using a long shutter speed: I used colored lights to accentuate the motion, with a brief burst of flash to make her appear sharp at the end of the exposure. As she was moving relatively quickly through the image and the shutter speed was very slow (around 2 sec.), her movement is not frozen or clearly defined, which gives the image a sense of motion and dynamic energy. Although you can't clearly see the dance moves she made, there is a real feeling of movement and action.

Everything else you need to know
Abstraction **34–35**
Camera modes **42–43**

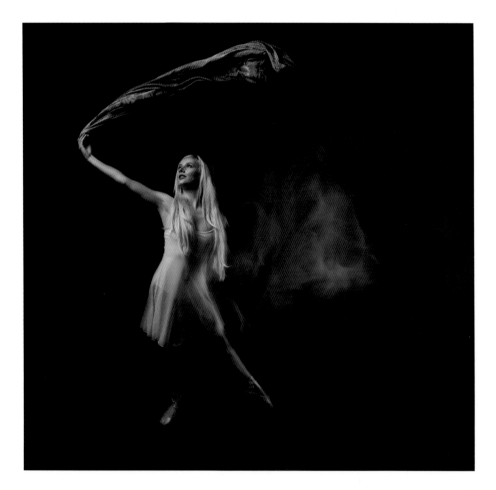

Panning
Moving at the speed of light

You have just seen how using a slow shutter speed with a moving subject will blur it as it moves through the frame, but what if you want to capture the essence of motion as a blur, while still keeping the subject identifiable and sharp?

This is where panning comes in. Panning is a technique where you use a slightly slow shutter speed and follow the subject with the camera as it moves, at the same time as taking the photograph. This will cause the background to blur, but the subject will stay pretty sharp, giving you a sense of speed and movement in your image. Although this can initially be tricky to do, with practice you'll quickly get the hang of it.

The key here is to get the shutter speed right. Too fast and it will simply freeze the movement, too slow and you risk your subject blurring beyond recognition. However, there is no single "correct" shutter speed, as it will depend on the subject's speed and distance from the camera.

It will also help if you look for a background that isn't too plain, or you won't really capture much sense of movement. Then, try to anticipate where the subject will be moving and follow it with your camera as it passes. Take care not to move the camera up or down, but to follow the subject smoothly as it passes by. The continuous drive mode function can help, as the camera will continually take pictures while the shutter-release button is pressed and you can then choose the best one.

Why this photo works
CLASSIC CAR

I wanted to create an image that captured the essence of the vintage cars that Cuba is known for and decided to use the panning technique to capture a sense of movement. Using a slow shutter speed and panning the camera has resulted in the background and road becoming blurred, while the car itself remains sharp. This gives a sense of motion that creates a much more dynamic and engaging shot.

Everything else you need to know
Shutter speed **50–51**
Backgrounds **118–119**

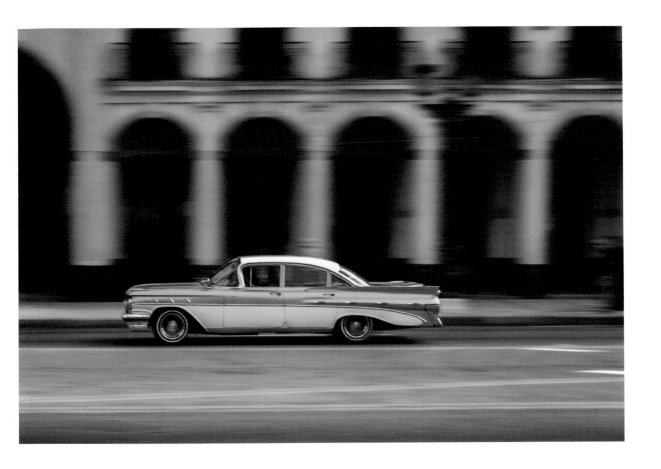

ISO
Cameras have feelings too

Your camera has a sensor that is sensitive to light and the ISO is how you can control this sensitivity. The lower the ISO number you choose, the less sensitive the camera will be. The lowest setting (known as the "base ISO") is usually either 50 or 100, and each time you double the ISO (from 100 to 200, for example) the sensitivity increases by one stop.

But what does this actually mean, and how can it help your photography? Well, there will be times when there just isn't enough available light for you to set a fast enough shutter speed to handhold the camera without introducing camera shake. Now, you could open up the aperture to let in more light (assuming you have a wider aperture setting on your lens), but this would also affect the depth of field in your image. The alternative is to increase the ISO, which would effectively make the sensor more sensitive to light, enabling you to use a faster shutter speed without changing the aperture.

So why not just use a high ISO all the time to enable fast shutter speeds? Because there is a trade-off. As you increase the ISO, the image quality will start to degrade as "digital noise" begins to affect the image. This noise reveals itself as a grainy texture, although the amount of noise you see will depend on your camera (specifically the size and quality of its sensor) and how high you push the ISO.

Why this photo works
METAL AND GLASS

I liked how the lights from these modern skyscrapers lit up the area and caused the low cloud to glow in the sky, but I didn't have my tripod with me. So, a handheld shot was the only option. I could have opened up the aperture to let in more light, but this would have affected the depth of field and how much appeared in focus. This meant that I had no choice but to increase the ISO. It is better to have a sharp noisy picture, rather than a blurry one, because most software can reduce noise relatively well in postproduction.

Everything else you need to know
Aperture **44–45**
Shutter speed **50–51**

Metering
Getting in the zone

Your camera has a built-in lightmeter that will work out what it thinks is the correct exposure based on the range of light and dark tones in a scene. Although it isn't always perfect, it usually gives you a great starting point for your base exposure. Most cameras offer the following three metering options:

Multi-area metering is also known as **Evaluative**, **Matrix**, and **Multi-segment metering** depending on the make of camera. It is usually the default metering option and bases the exposure on a light reading for the whole scene, often by breaking the scene down into multiple areas (or zones) and averaging out the results. It is usually pretty accurate unless there are tricky lighting conditions or the scene is predominantly bright or dark.

Center-weighted metering is similar to the default mode above, but instead of metering the whole scene, the camera determines the exposure from the central area. The idea is that the main subject is unlikely to be at the very edges of the frame, so these areas can be discounted.

Spot metering reads the brightness of a very small part of the frame, either at the center of the frame or from the active focus point, and uses this tiny area to determine the exposure for the rest of the image. This is useful in tricky conditions, but you do need to ensure that the exposure reading is being taken from a midtone area, rather than a highlight or shadow.

Why this photo works
HALLGRÍMSKIRKJA CHURCH

Your camera's lightmeter can struggle when there are a lot of bright (or dark) areas in a shot. Here, the stark white interior of this church in Iceland confused the camera and it initially tried to underexpose the image, meaning that the walls looked gray instead of bright white (photographing in snowy conditions usually has a similar effect). It therefore pays to check the histogram and correct any under– or overexposure when you suspect the camera might not give an accurate result.

Everything else you need to know
Histograms **64–65**
Exposure compensation **66–67**

Dynamic range
What you see isn't always what you get

Our eyes are truly incredible, and constantly adjust to let us see detail in the bright highlights, dark shadows, and everything in between. The difference between the brightest and darkest points in a scene or photograph is known as its "dynamic range"—the greater the difference, the higher the dynamic range.

However, while our eyes can adjust to the dynamic range of a scene, our cameras cannot. Cameras have a fixed dynamic range that can be more restricted than our vision. What this means is that when you take a photo of a scene that has a very wide range of tones between the brightest and darkest areas, your camera may not be able to capture it properly. Depending on the chosen exposure the image may have shadow areas that lack detail, highlight areas that are "burned out" and white, or both.

There is no quick fix to this problem, so you may have to compromise and decide which area in your image you want to be correctly exposed. Alternatively, you could consider using an external light source, such as a flash, to brighten darker areas, or shoot a sequence of images at different exposures and combine these in postproduction to create a single High Dynamic Range (HDR) image. Shooting Raw images will also help you capture a greater dynamic range than a JPEG file. Over time it will become easier to identify when the dynamic range in a scene will be problematic and what steps you need to take to deal with it.

Why this photo works
THE STAIRCASE

This image was taken inside an old hotel and shows a common scene that can test your camera's dynamic range. The bright window above the staircase was overexposed in my first shot because the camera was unable to balance the brightness of the window with the darker interior. To fix this I used a small amount of negative exposure compensation. Although this made the interior darker than I would have initially liked, I had to compromise to ensure a more well-balanced image and was able to lighten the darker areas during postproduction. Generally speaking, it is better to underexpose an image slightly and then brighten it, rather than overexpose it, as lost highlight detail is impossible to recover.

Everything else you need to know
Metering **60–61**
Exposure compensation **66–67**

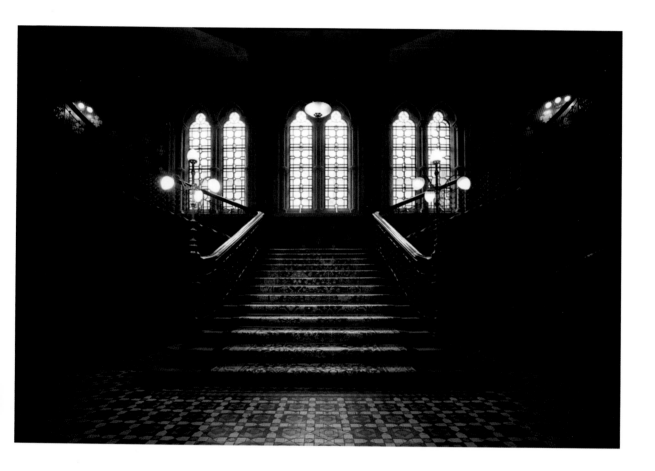

Histograms
Everything explained in black and white

No one really likes to think of graphs when it comes to photography, and histograms cause a lot of confusion, but they are really quite simple when you get to know them. A histogram is a visual guide showing the distribution of all the tones in an image. Using a graph format, the histogram shows black at the left and pure white at the right (with all the other tones in between), while the vertical axis—the "peaks" on the histogram—show the amount of these tones that appear in the shot.

The shape of a histogram depends entirely on the scene you are shooting, so there is no "correct" shape—the histogram is simply there to help you determine the correct exposure at a glance. The histogram for a "well-exposed" general scene (without extreme light or dark areas) will usually have the peaks concentrated toward the middle of the graph, which represents a spread of different midtones. However, if your image is of a bright subject, the histogram will have higher peaks at the right side to show the brighter tones. Conversely, if an image is made up primarily of dark tones you will have a lot of peaks toward the left side of the graph.

A histogram can be really helpful in showing you where parts of the captured image are completely black or white. This would be shown as a spike at the respective end of the histogram, as if the graph has gone "off the scale." When this happens it indicates that no detail has been recorded in either the darkest or brightest parts of the image (or both), depending on which end goes off the chart. In either case, you may need to fine tune your exposure to bring detail back into the tonal extremes.

Why this photo works
LAKE DISTRICT REFLECTIONS

This image has a broad range of tones, from the very bright sky to the dark shadows of the treeline, with a range of midtones in between. The histogram below shows this information as a graph. The spread of peaks range from the dark tones at the left, through the midtones, to the lightest tones at the right. As the graph doesn't go "off the scale" at either end, this tells me there are no pure black or white tones in the image, so no detail has been lost.

Everything else you need to know
Metering **60–61**
Dynamic range **62–63**

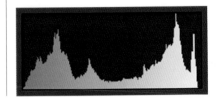

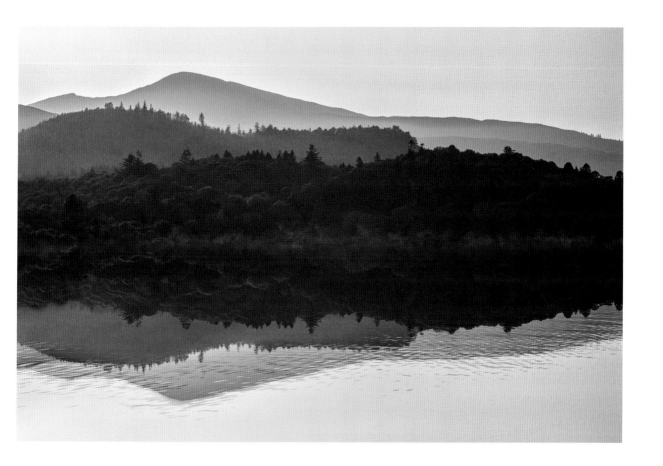

Exposure compensation
A secret in the shadows

Your camera's exposure meter usually does a pretty good job at determining the brightness of a shot, but sometimes it can struggle to find the correct exposure. You might find it trying to overexpose bright areas or underexpose darker parts, but there's a really quick fix for this.

Exposure compensation is a function that allows you to override your camera's chosen exposure. If your camera is making things too dark, dialing in some positive ("+") compensation will brighten the exposure. The opposite happens when you apply negative ("-") compensation, with the overall exposure becoming darker. This can be an easy way to fine tune your exposure when you're shooting in Program, Aperture Priority, or Shutter Priority mode, and it's a great alternative to shooting in Manual mode.

Try applying small amounts of exposure compensation to see how they affect your image, and gradually build them up slowly until you reach the desired exposure. You'll soon find that you can estimate how much you need to apply for a particular scene or result. When you've finished, be sure to reset your exposure compensation back to its neutral "0" position. Otherwise it will stay where you left it and you will apply the same adjustment to your next shot.

Why this photo works
FROZEN TAXI

This image of a frozen taxi on a snowy day in New York City was giving the camera's exposure meter a hard time. The camera was underexposing the image, thinking it should not be as bright as it really was, and this resulted in the snow appearing gray and dull. To fix this I dialed in some positive exposure compensation, but had to make sure I didn't dial in too much and start losing detail in the brightest areas.

Everything else you need to know
Metering **60–61**
Histograms **64–65**

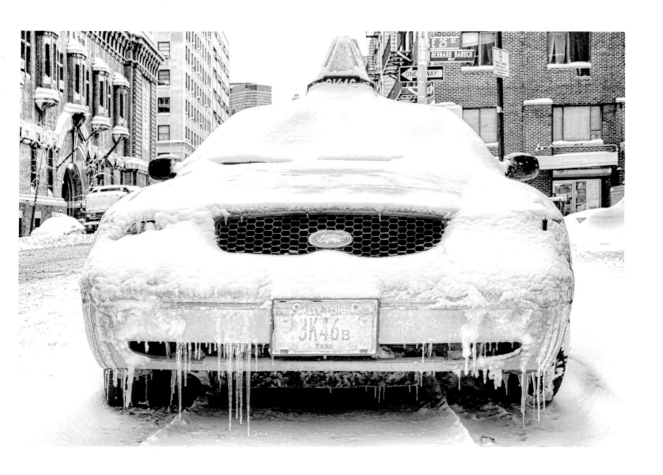

Everything you always wanted to know about light

Light
Light is everything

Photography is all about light and how you use it to capture and accentuate what you are photographing. With every scene or subject, different light can result in a very different image.

The "intensity" of light means how strong it is and how much of it you have. This determines the exposure. Too much light can lead to a bright, overexposed image. Too little can lead to a dark, underexposed one. As outlined in the previous chapter, you use your camera's exposure settings to control this.

A light source can be either natural or artificial, and each type of light will give off a distinctive color, referred to as its color temperature. Sunlight is the main source of natural light, and its color temperature largely depends on the time of day. At sunrise and sunset it will often be orange/red; in the afternoon it will be a warm yellow; at dusk, cool blue tones dominate, and so on. The colors of artificial light sources depend on what is creating the light. LED bulbs produce a cool blue tint compared to a streetlight, which gives off a strong orange hue.

These colors will clearly affect your images and influence how your viewers see and interpret your photographs. Blue light is "colder" and gives a sense of both mystery and tranquility, while orange and yellow are naturally seen as warmer and give viewers a greater sense of happiness and joy.

Why this photo works
WELSH LIGHTHOUSE

I wanted to accentuate the peace and tranquility of this location so needed soft light to create a soothing scene with no dramatic hard shadows. However, the sun was high and the light was intense when I arrived, so I had to wait for the sun to move lower in the sky. You can see how the soft light has drawn out the shadows and how this helps to accentuate the shapes of the stone cross and the lighthouse.

Everything else you need to know
Camera modes **42–43**
White balance **80–81**

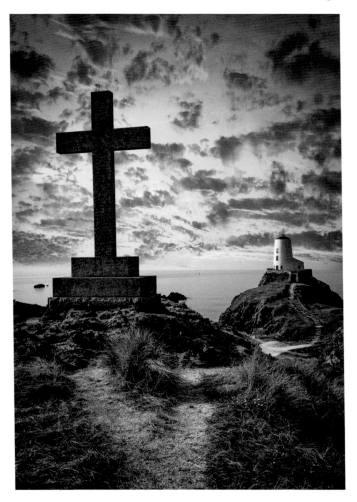

66 The intensity of light is how strong it is and how much of it you have. 99

Hard light
Drama in the shadows

Hard light simply refers to the intensity of the shadows that are produced when light shines onto a subject. With a hard light source these shadows are strong and dark, with a sharp edge. This type of light usually comes from a small, concentrated light source, such as a flashlight or vehicle headlights. The midday sun is another example of a hard light source; although the sun is large, its distance makes it seem relatively small and strong.

The intensity of hard light can be difficult to control, as it typically creates high contrast between the brightest and darkest areas. This can lead to strong shadows that often appear black and lack any detail, or brighter areas that are washed out. Your camera might struggle with this high dynamic range, so keep an eye on the histogram and be prepared to use exposure compensation.

Although it is often described as an "unflattering" light (especially for portraits), hard light can create strong, graphic images and—when used well—can increase the drama in a scene and create a shot that is full of energy and expression. The brighter areas can be used to draw attention to a subject, with the darker shadows masking out unnecessary detail. This can work particularly well in black and white.

Why this photo works
MIAMI MODERN

The strong shadows created by the hard light of the bright sun can be used to accentuate lines and curves, and add an additional dimension to your photographs. In this architectural shot of the side of a building, the sunlight created a hard shadow around certain elements, which adds interest to the image and helps to highlight some of the architectural details. The hard light has also washed out some of the intensity of the colorful paint on the building.

Everything else you need to know
Histograms **64–65**
Exposure compensation **66–67**

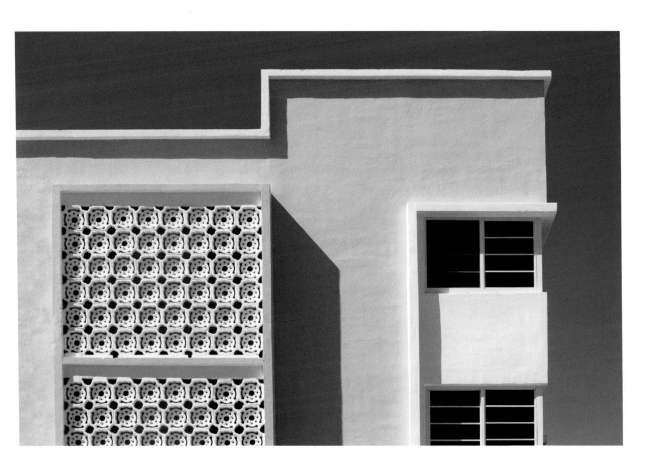

Soft light
Looking for tranquility

Soft light is the type of light that most photographers crave and go to great lengths to find or make. It is created by a large light source, or a smaller light source that has been diffused, and produces soft shadows that are long and gradual. They are not as well defined as those created by hard light, with smooth transitions into the shadow areas and a wide range of midtones.

Images taken when the light is soft can seem more tranquil than those taken with harsh, hard light. However, depending on the subject, the lack of strong shadows can also create a low-contrast image that is lacking in drama or dimension. Look out of a window on a cloudy day and see how flat the scene appears without any strong shadows.

Outdoors, the angle of the sun and cloud cover can affect the intensity of the light. When the sun is low in the sky (at either end of the day) it is much softer, and produces images with lower contrast than when it is high in the sky.

Why this photo works
FOREST DAWN

The soft light in this image accentuates the stillness of the forest at dawn. The sun had barely risen, so the light still had a blue tint, which creates a sense of mystery, but also one of peace and calm. As the trees disappear into the brighter hazy light they draw your gaze into the scene; if this image had been taken a few hours later, the soft light would have been replaced with strong shadows and the mood would have been completely different.

Everything else you need to know
Dynamic range **62–63**
Histograms **64–65**

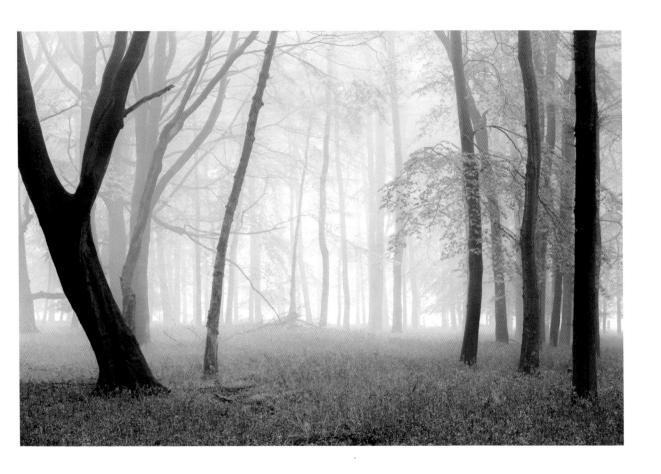

Low-light photography
Learning to see in the dark

Photographing in low light can produce really stunning images that are full of energy. It can be challenging, though, as there is less light available and you have to have a thorough understanding of exposure to be able to capture your subject or scene properly. However, the results of shooting after dark can be really rewarding as lights come on and start to illuminate the scene. At night, a city can take on a cinematic feel that really engages the viewer. We are all naturally intrigued by images taken when most people are indoors, as we get to see what we don't ordinarily see.

In low-light conditions you will inevitably end up using very slow shutter speeds, so camera stability is key. It can be really disappointing to return home with blurry images, and although some cameras and lenses have image stabilization, this won't really help you with the very long shutter speeds you'll need. The best way to ensure your camera doesn't move is to use a tripod (although even resting the camera on a wall will help), and if you can use a remote release to trigger the shutter this can help avoid you accidentally shaking the camera as you press the shutter-release button. If you don't have a remote release, use your camera's self-timer function instead.

The bright lights of a city can make fantastic compositions, but other landscapes can be equally beautiful after the sun has set. Moody, ethereal images can be made as the light begins to fade, and shadows and darkness become more pronounced. Countless opportunities reveal themselves after the sun has gone down.

Why this photo works
LONDON POWER STATION

It can be easy to be dazzled by all the lights at night, but you still need to think about your composition. In this image, the movement of the trains left colorful light trails as they sped through the scene; their fast speed meant that only bright streaks of their lights were captured in the exposure. For a shot like this you need to put your camera on a tripod and use a remote release to try and time your exposure with the flow of traffic.

Everything else you need to know
Camera modes **42–43**
Dynamic range **62–63**

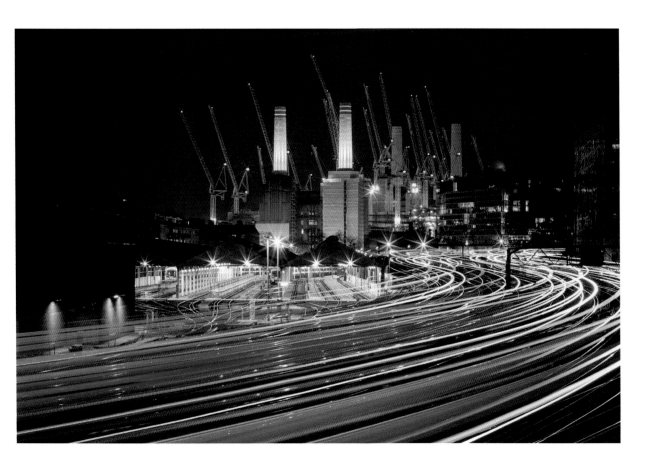

Directional light
Becoming a lighting conductor

Directional light refers to the position of the light source in relation to the subject. Light can fall on your subject from any angle, and different directions can have a huge effect on the overall look of your images.

Perhaps the most common direction is overhead light from the sun, high up in the sky. This is not considered very flattering and it takes practice to use masterfully due to the harsh shadows it creates.

Lighting from below is rarely used, as it looks unnatural—we are used to things being lit from above by the sun. Think of those old horror movies and the monsters in them, which often looked scary as a result of being lit from below.

Lighting from the side can be a good way to reveal the shape and texture of your subject. You can create long shadows using this form of lighting, which will help produce very dramatic shots that are full of depth and volume. The downside is that the subject will not be lit evenly, so one side of it will be much brighter than the other.

Back-lighting is where the light comes from behind the subject. This can produce exciting images—including silhouettes—but shooting into the light might confuse your camera, so watch your exposures. Depending on the strength of the back-light you may want to use a fill light, such as flash or a reflector, to throw some additional light onto the front of your subject. Alternatively, you could increase your exposure to add detail to the subject, although this would be at the expense of overexposing the background.

Why this photo works
ABANDONED

This classic car in a derelict garage was bathed in soft, directional light. You can see that the light is coming into the scene from the top left of the image, as it only illuminates the floor and the front of the car. Where the light falls away, the shadows are long and drawn out to the right side of the picture and they eventually fade into complete darkness. This creates a strong sense of mood and drama, and gives the image a cinematic feel.

Everything else you need to know
Metering **60–61**
Silhouettes **82–83**

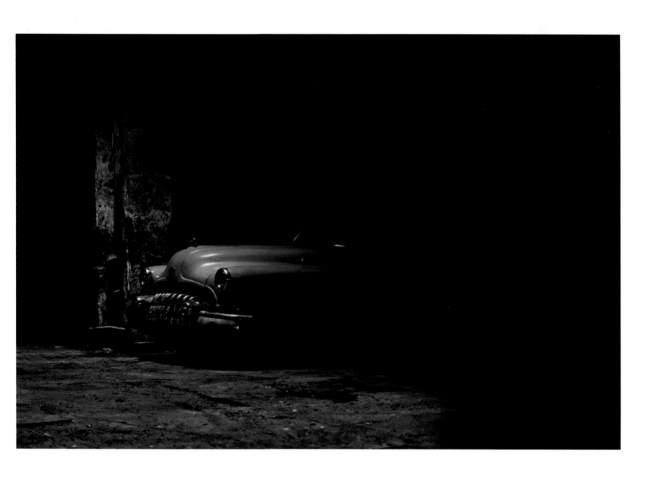

White balance
Not too hot… not too cold

Sometimes when you take a photograph you will notice that the colors aren't quite the same as those that you have seen with your eyes. This is because your eyes and brain have the ability to adapt and interpret any slight shifts in color, so a sheet of white paper will look white to us under a desk lamp, the midday sun, or even by a fireplace; you know the paper should be white and you see it that way.

Your camera is not so smart. You need to tell it what kind of light source you are shooting under, so it can apply the appropriate color correction. This is done using the white balance setting. The default setting is **Auto** white balance, which is where the camera estimates the correct white balance setting. This will be pretty accurate a lot of the time, but if it struggles you can step in and choose a preset option to match the light you are shooting under. The preset options typically include settings for **Daylight**, **Shade**, **Cloudy**, **Incandescent**, **Flash**, and **Fluorescent** light sources.

For very tricky situations (or when you want an extremely accurate result), most cameras also have a **Custom** white balance option. This usually involves using a white or gray card to set the camera's white balance before you take your shot.

As well as being used to avoid color shifts, white balance can also be used creatively to add a color tint to your images. Using the Incandescent setting in daylight, for example, will add a blue tint to an image. Play around with the other options and see how they affect your shots.

Why this photo works
VENETIAN GONDOLIER

This image of a canal and a gondolier in Venice contains a mix of artificial and natural light, which influences the colors in the scene. Taken early in the evening, under a stormy sky, the clouds and buildings took on a cool blue tone, while the artificial lights gave off a strong yellow/orange light. The camera's Auto white balance did a pretty good job, but as I was shooting Raw I could also correct the color during postproduction.

Everything else you need to know
Thinking in color **36–37**
Sunrise & sunset **84–85**

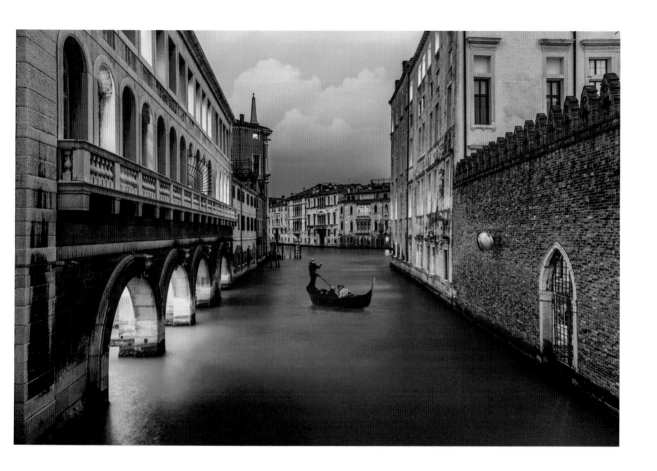

Silhouettes
Don't be afraid of your own shadow

Silhouettes are a great way of adding the "wow factor" to your photographs, while dealing with some difficult lighting conditions. They can also add a real sense of drama and mystery, although there are a few considerations when taking this type of image.

The idea with a silhouette is that the light source is behind the subject, facing the camera, and the subject is made as dark as possible. If you're shooting outdoors in daylight, base your exposure reading on a bright patch of sky (but not directly from the sun!) so the sky is exposed correctly, while your foreground and subject fall into dark shadow. If your silhouette is not dark enough, apply some negative exposure compensation to darken down the shadows even more.

Don't forget that you still need to consider the composition and nail the focus on the subject as well. Try to choose a subject that has a simple shape or form, as the lack of detail may make it difficult for your viewer to identify a complex object. That said, interesting abstract shapes and outlines can also be used creatively as a silhouette. Shooting black-and-white silhouettes can add an extra degree of drama and really grab your viewer's attention.

Why this photo works
RED SUN

The sun was setting with a stunning red color and I decided to use a telephoto lens to compress the relative distance between the tree and the mountains so they looked closer together. This also helped to make the sun appear larger and more prominent in the sky. The camera's exposure meter initially tried to overexpose the scene, leading to washed-out colors, so I applied a small amount of negative exposure compensation to ensure the tree appeared very dark. This also helped to darken down the rest of the scene and make the sunset colors appear more saturated.

Everything else you need to know
Exposure compensation **66–67**
Directional light **78–79**

Sunrise & sunset
What goes up always comes down

Sunrise and sunset are wonderful times to photograph, as the amazing colors can really create some beautiful images. Having the sun low on the horizon provides a pleasing soft light that is full of warmth and wraps around everything in its path.

There is a delicate balance when it comes to setting the correct exposure, as you want to avoid overexposing the beautiful colors in the sky, but you also need to ensure your subject isn't underexposed as a result. You need to pay attention to the white balance as well. Set to Auto white balance, your camera will likely try to neutralize any color in the sky, so using a Daylight preset may be preferable (or Shade/Cloud for added warmth).

Shooting landscapes is the obvious option at either end of the day, but it can be easy just to focus on capturing the "main attraction" of the setting sun. However, there are often wonderful things happening to the sky in the opposite direction, so don't forget to look around. Once the sun has set, don't be too quick to rush off. Wait and watch as the sky changes. Often, some of the best colors appear just after the sun has dipped below the horizon, when most photographers have packed up and left.

Sunrise and sunset don't just work well for landscapes. They are also great times for portraits, although you have to take extra care to avoid camera and subject movement as there is less available light, which will often result in longer exposure times.

Why this photo works
SUNFLOWERS

Faced with a beautiful sunset, it can be easy to focus on the sky and overlook the rest of your composition. Quite often, though, the most interesting element is not the sun, but the way in which the sunlight interacts with the wider scene. So, make sure that you try to incorporate other elements in your images, such as the field of sunflowers here. This gives the viewer a variety of things to look at in your photograph, not just the sky. There are plenty of apps and websites that can give you sunrise and sunset times for specific dates. Check ahead to see when the sun is due to set or rise, and try to get to the area early. That will give you the chance to look around and find an interesting composition or viewpoint so you can set up in advance.

Everything else you need to know
Thinking in color **36–37**
White balance **80–81**

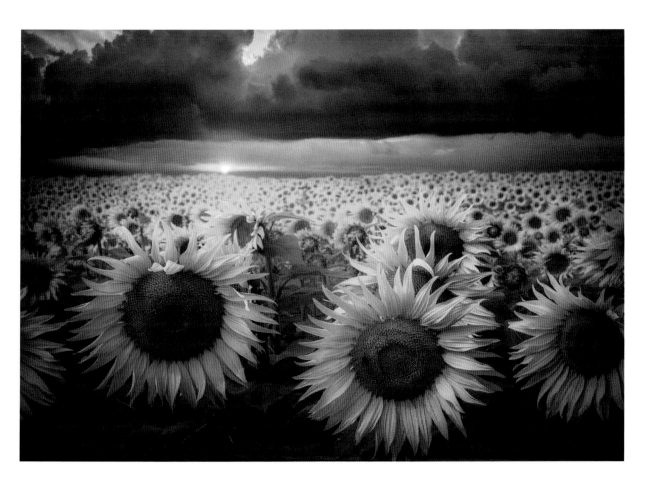

Everything you always wanted to know about lenses

Lenses
The photographer's eye

In the pages ahead you will see how different lenses can impact your images, but before we look at the details there are a few fundamental concepts that apply to all lenses:

Focal length is the distance (usually in millimeters) from a lens' optical center to the focal plane (sensor) in the camera. In practical terms it gives an idea of the lens' field of view.

Field of view indicates how much of a scene a lens can "see." A short focal length has a wide field of view (so is known as a "wideangle lens") and will fit more of the scene into a photograph and capture a broader overall image. Conversely, a longer focal length (known as a "telephoto lens") has a narrower field of view, which limits how much of the scene is included in the frame.

A **prime lens** has a single, fixed focal length, which means the only way to change your composition is to physically move around. Prime lenses tend to be smaller and lighter, and they can also have a wider maximum aperture than a zoom lens covering the same focal length.

A **zoom lens** covers a range of focal lengths, which enables you to change the field of view without having to physically move closer to, or further away from, your subject. While this is hugely convenient, zoom lenses tend to be bigger and bulkier than prime lenses, and sometimes (although not always) the image quality is not as good.

Sensor size refers to the physical dimensions of the camera's sensor, and although this is not a lens feature it can have a profound impact on your images, as shown opposite.

Why this photo works
SÈVRES BABYLONE

The size of the camera's sensor affects the field of view of a lens. The detail below shows the full image taken with a camera with a full-frame sensor (which delivers the full angle of view from a lens); the result of using the same lens on an APS-C crop-sensor (magenta frame); and the field of view recorded by a Micro Four Thirds camera (cyan frame).

Everything else you need to know
Filling the frame **30–31**

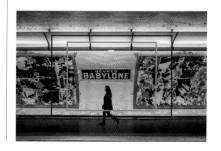

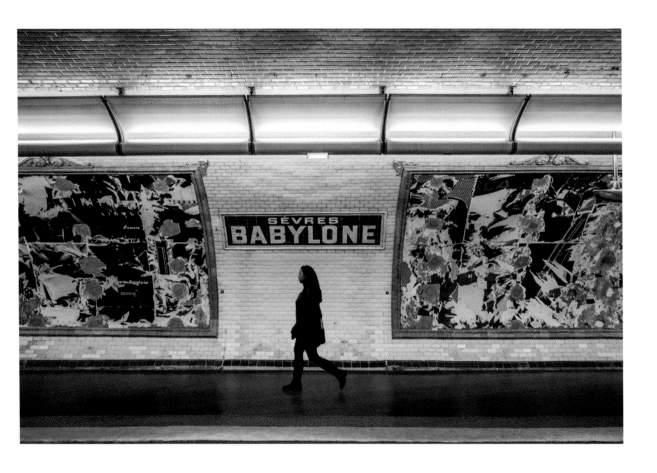

Wideangle lenses
Building up layers

When you find yourself standing in front of something large that you would like to photograph, such as a sweeping mountain view or a large skyscraper, a wideangle lens is the natural choice. It means that a lot of the scene will be captured and this can be helpful if you just want to "fit it all in" to a single image.

However, this can easily lead to a shot with no real focal point. There is often so much in the frame that the viewer can get lost in the expanse of the scene, and it ends up lacking interest. It can also be tricky to create a compelling photograph, as the wide field of view of the lens will appear to affect perspective and distort your scene. Objects in the distance will appear much further away, while objects close to the camera will appear larger and angles will be exaggerated. This can be difficult to balance in a photograph, because you don't necessarily want to push objects in the distance so far back that they become insignificant, nor will you always want the foreground to dominate the frame.

Therefore, a shot taken with a wideangle lens needs careful consideration. It is important to try and include something interesting at the different "layers" in an image, from foreground to background, as that will help make the photograph feel three-dimensional. Try to build up your composition with something significant at the front of the image and other elements leading the eye toward the background. Strong leading lines can work well here.

Why this photo works
THE GLASS PYRAMID

I wanted to photograph the Louvre Museum in Paris at night, with the lights highlighting the blend of modern and old architectural designs, and knew I would need a wideangle lens to capture the vast pyramid and include the older buildings in the background. Knowing that the lens would distort angles, I chose to shoot from a low position, close to the walls around the fountains. This created strong diagonal lines that draw the eye along them to the older buildings, while the modern pyramid appears bold and dramatic at the center of the frame.

Everything else you need to know
Leading lines **16–17**
Angle of view **22–23**

Telephoto lenses
Removing distractions

A telephoto lens has a long focal length and narrow field of view, so it appears to magnify distant subjects (a bit like a telescope). This can be incredibly useful if you want to photograph a subject that is far away, or something you can't, shouldn't, or don't want to get close to! The narrow field of view of a telephoto lens also allows you to select a specific part of a scene, or to create an image that removes potentially distracting elements.

When using a telephoto lens you have to be aware of compression and how this affects the elements in your photographs. Compression is where the lens appears to reduce the spatial distance between objects, so they appear squashed together, making it difficult to determine how far objects are from each other.

You also need to watch out for camera shake when using a telephoto lens, as the effect of any movement will be much more pronounced. Image stabilization can help, but it is best to use a tripod wherever possible to ensure that your image is sharp.

Why this photo works
THE MOUNTAINS

This image of the mountains in the Alps was taken from a small village in the valley below, using a telephoto lens. You can see the strong effects of compression from the telephoto lens: it has flattened out the perspective so the trees in the lower left and mountains appear to be almost on top of each other. It also creates the illusion that the distance between them and the camera is not that far. The peaks appear to be extremely close together and the distances between them flattened out.

Everything else you need to know
Angle of view **22–23**
Filling the frame **30–31**

Standard lenses
20:20 vision

A standard (or "normal") lens refers to a focal length that delivers a field of view which is similar to our eyes: this is accepted to be around 45–50mm on a full-frame (or 35mm) camera. Unlike wideangle lenses, which introduce a lot of distortion, or telephotos that magnify distant objects, a standard lens provides a natural view of subjects that is not distorted or overpowering.

A typical standard lens is a 50mm prime lens with a wide maximum aperture in the region of f/1.8 or f/1.4. The term is also accepted to include "standard zoom" lenses in the range of 35–70mm (or the 18–55mm zooms provided as part of a "kit" with crop-sensor cameras), although many standard zooms have a smaller maximum aperture.

Standard lenses can be used to photograph a whole variety of subjects, but they are very popular as portrait lenses. Not only do they let you get close to the person you are photographing without putting you so close that you are invading their personal space, but, as they don't exaggerate any part of the subject, they create the impression that the subject is being seen in a natural "through-your-eyes" way. A prime lens with a wide maximum aperture is also great for producing a shallow depth of field and throwing the background out of focus.

Why this photo works
CANDY DRESS

This high-key portrait was taken with a 50mm standard lens on a full-frame camera. This enabled me to stay relatively close to the model in the small studio, but still capture her without any of the unflattering distortions that a wideangle lens would have caused. As with all photographs of people, it was critical that her eyes were in sharp focus, and as I wanted a slightly deep depth of field I chose an aperture of f/11. Using studio strobes ensured I had sufficient light to achieve a fast shutter speed and low ISO for the desired bright exposure.

Everything else you need to know
Shallow depth of field **46–47**
Lenses **88–89**

Macro lenses
It's all in the detail

The macro world is a fascinating place where tiny details are enlarged to life size and beyond, and you can see things that are not easily seen with the naked eye. A true macro image is one where the subject has been captured at the same size as it is in real life, although most close-up images are also referred to as macro photographs.

When you want to take a photograph of something small, the easiest option is to use a macro lens. This is a specialist lens that lets you get up close to tiny subjects and make big pictures of them. Macro lenses are usually prime lenses that can focus down to a very small distance, so you can position your subject right in front of the lens.

The biggest challenge when taking macro photographs is depth of field as, even when you use a very small aperture, the depth of field can be tiny. If your subject is flat and your lens is straight on to it, this might not be a problem, but shooting at an angle or photographing something that is three-dimensional can be tricky.

Why this photo works
CHERRY BLOSSOM

This lone cherry blossom flower stood out on a tree in full bloom and I decided to shoot it with a macro lens to emphasize its detail and beauty. Despite shooting with a small aperture of f/16, the depth of field is tiny. The branch at the front of the image falls quickly out of focus and the other blossoms in the background appear as a blur of color, so the main flower literally pops off the page, rather than getting lost in a multitude of other flowers.

Everything else you need to know
Abstraction **34–35**
Deep depth of field **48–49**

"A true macro image is one where the subject has been captured at the same size as it is in real life. "

Filters
Through the looking glass

A filter is a piece of glass (or resin) that you put in front of the lens to achieve a certain effect. A variety of filters is available, which can do a multitude of things, from blocking light to adding colored effects. The most common type of filter fits to the front of your lens, so you need to make sure you have the correct size filter for your particular lens.

The most popular filter for landscape photographers is a polarizing filter, which acts as sunglasses for your lens and can help reduce glare and saturate the colors of the scene in front of you. It can also reduce reflections from reflective surfaces, such as water. To control the polarizing effect you rotate the filter, but if you are setting your exposure manually you will need to be aware that the filter reduces the amount of light, which will affect the exposure.

Another popular type of filter is a neutral density (ND) filter, which is a "darkening" filter that simply reduces the amount of light passing through it. The main benefit of ND filters is that they allow you to use much slower shutter speeds during the day, which can help to add a surreal soft blur to moving objects such as clouds or flowing water. ND filters come in different strengths, which refer to the amount of light they block. The stronger the filter, the darker it is.

Why this photo works
CHECKERED BUILDING

An ND filter can be great for removing people from popular places and creating empty views in locations where it wouldn't otherwise be possible. This image was taken at the middle of the day and people were continually walking down the pathway between the buildings. However, using a 10-stop ND filter extended my shutter speed (exposure time) to more than 4 minutes. As a result, none of the people were recorded in my image because the camera did not receive enough light to capture them as they moved through the shot. The long exposure also recorded the movement of the clouds as streaks in the sky. A sturdy tripod and remote release were essential to make sure the camera didn't move during the exposure.

Everything else you need to know
Making it minimal **32–33**
Blurring motion **54–55**

Everything
you always
wanted to
know about
creativity

Creativity
Thinking outside the box

Creativity is really just using your imagination to make something original. But with hundreds of millions of images out there in so many forms, how do you make compelling photographs that stand out? How do you make your photography interesting and unique, and appealing to those who view it?

For a start, you need a subject that has some interesting feature or element and the basic technical skills to capture it. But it goes beyond that. You also need the inventiveness that only you have. You need the ability to put your own spin on what you see, show how you feel, and talk to your viewer through your images. What you want to end up with is your own individual vision.

Sure, you may be in front of a famous landmark that is photographed thousands of times a day, but stop and think about how you can put your own stamp on the image. Can you make it "yours" compositionally, or by using blur, or by making it abstract, or through the use of movement, or playing with light, or some other setting? There are countless options at your disposal, so think about how they can be used or combined to create something that is unique. How you choose to do this is down to you. This is all about *your* creativity.

Why this photo works
MAN IN THE HAT

With this shot I wanted to play with the theme of implied distance and time. I had the idea of creating a double exposure—two separate images—of someone up close and then further away, and combining them to give the illusion that people could be up close, yet feel far away at the same time. I came across this lonely dirt road, which provided the perfect backdrop, and returned to take the picture a little time later. With the concept already in my mind, it didn't take long to create the image.

Everything else you need to know
Abstraction **34–35**
Panning **56–57**

66 You need the ability to put your own spin on what you see, show how you feel, and talk to your viewer through your images. **99**

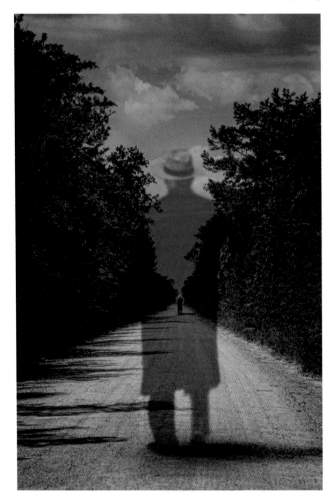

Looking not seeing
See things through different eyes

Our eyes are vital for our photography. This might seem obvious, but how we see things in front of us plays a much bigger role than you might realize. I don't mean in the physical sense of "seeing," as all our compositions will be based on what we see, but in terms of our *thoughts* as we look. How we are feeling about the subject we are looking at and our interpretation of those feelings are essential parts of the creative process.

Of course, you need the equipment and the technical knowledge to capture what you want, but it goes further than that. There is also that special something that you add to your shot; your personal interpretation of the view in front of you, what you choose to reveal, and how you do it. The shutter-release button is the last part of the creative puzzle of photography.

Take the time to wander and to let your mind wonder. Think about what you are hoping to create and show. Do you want to confuse your viewer, fill them with questions and intrigue, wow them, or make them feel emotion? When you have your answers, that is when you are ready to take your shot.

Why this photo works
DISCS

This modern building is covered in thousands of metal discs. I wanted to highlight the architectural shape of the building and its patterns, and thought that a black-and-white shot would remove any distractions and create a stark, contrasting image. I chose a small aperture to ensure that all the discs were in focus, and as the sky was cloudy and uninspiring I used an ND filter to extend the exposure and capture some of the movement of the clouds. I had to imagine a lot of these things before taking the picture, so thinking about what I wanted the final image to look like happened before I took the shot.

Everything else you need to know
Blurring motion **54–55**
Filters **98–99**

Telling your story
What are you trying to say?

When choosing what to photograph you are in complete control over what the camera captures and what the viewer sees. Your final photograph is a small window into what is going on around you when you fire the shutter, so you have to decide what to include in your image and what is not adding to the story.

As you have limited space within the frame of a photograph to effectively convey what it is you want to say—what you see, or hear, or feel from a particular place, person, or scene—you have to decide what it is that you are trying to convey to the viewer. Is it a straightforward and obvious message or idea? Is it a photojournalistic image, merely showing the subject or scene in a clear and unambiguous way? Or are you actually trying to create something more complex—something that implies a feeling or meaning?

Ambiguity can be a strong way to encourage the viewer to think about something and to lead them toward the message you are trying to convey. Sometimes not making it too obvious for the viewer can be more rewarding for them, as they will spend longer looking at your image and trying to decipher what you are trying to express. In this way, implying what it is that you are focusing on, or just making it less apparent at first glance, can be incredibly satisfying for the viewer.

Why this photo works
THE LITTLE GIRL IN BLUE

In this photograph of a derelict building, I wanted to convey the desperate living conditions of one particular family. The whole village was run down and this building was so dilapidated that I didn't think anyone could live there. At first glance, the image shows the poor state of the building, with no roof or windows, and the brooding sky helps create a somber mood. This leads the viewer in a number of directions—perhaps asking how the building once looked, or what had caused such damage. However, looking closer there is a young child looking back at the camera. She is carrying a box and appears to be heading inside. This suddenly creates a different journey and new questions for the viewer to consider. The slight delay in seeing her creates an added sense of mystery and provokes further thought.

Everything else you need to know
Balance & visual weight **20–21**
Angle of view **22–23**

Creating intrigue
Shooting questions not answers

When we create our images it is sometimes best to leave some of the messages in them vague, so the viewer can interpret the picture and figure out the questions and answers for themselves. Surprisingly, viewers will often find an image that is stripped of some detail really rewarding. This is because the power of the imagination is strong and a thought-provoking photograph that forces the viewer to consider what is going on can often become a compelling one.

The message in your photo doesn't need to be obvious to the viewer. The human psyche likes mystery and intrigue, and the challenge of determining what is actually going on in front of it. Your content can be selectively vague, which can pose a deliberate question, or it can retain some strong but ambiguous content that encourages your viewer to discover more about what is going on.

A photographer's ability to tap into the natural curiosity of the viewer can be an important creative tool. When this is utilized well, it can result in very powerful images.

Why this photo works
GIRL ON THE STAIRS

This captured moment creates questions and mystery for the viewer. What is the girl thinking about? Why is her head in her hands? Is it sadness, despair, or something else that has caused her to sit in such a way on the stairs? None of these questions are answerable, but the fact they pop into the viewer's mind creates additional interest and intrigue. It is human nature to relate to the human qualities in others; to try and empathize with the people we see in photographs and imagine what they are seeing or feeling.

Everything else you need to know
Angle of view **22–23**
Telling your story **106–107**

"A thought-provoking photograph that forces the viewer to consider what is going on can often become a compelling one. "

Making it happen
Having a plan for your picture

Quite often, hastily taken photographs end up looking like snapshots, because that is what they are. Many of the stunning images you see in magazines and online are part of a well thought out photographic process. The photographer hasn't just randomly chanced on a good photograph without any effort, but has usually put a lot of thought into the "what, where, how, and why?"

Sometimes, having the opportunity to revisit a location can produce very different results and you may be surprised at what you see when you return somewhere with "fresh" eyes. The light may have changed, and the location or subject may have altered in a significant way as well. What you may have previously felt was boring could now fill you with joy, and these different feelings and attitudes will have a pronounced effect on your images. You will also have the extra experience from your earlier visits to know what works or what doesn't (and why), and what can be improved upon (and how).

Don't just snap the obvious, either. Or, more specifically, snap the obvious, but don't stop there—move about and snap again. Repeat and look and take shots from all around. The more you shoot, the more you will find, and you will often surprise yourself with what you end up with. Some images will work well and some won't, but you will often find that you end up with one or two that are special, as well as some more ideas for your next visit.

Why this photo works
LAVENDER SUNSET

This is an image that I had in my head for a long time and wanted to create the first time I saw these lavender fields. I had wandered around and found my desired composition with the old tree, but I knew that I wanted the right light—the perfect mixture of colorful sunset and soft clouds—to accentuate the beauty and to complement the scene. This photograph took a number of attempts to achieve, with a few wasted journeys and time spent waiting hopefully for nature to create the sky I longed for. On my third visit, all the elements fell into place and my patience was rewarded with one of the most spectacular sunsets I have witnessed.

Everything else you need to know
Backgrounds **118–119**
Focus **120–121**

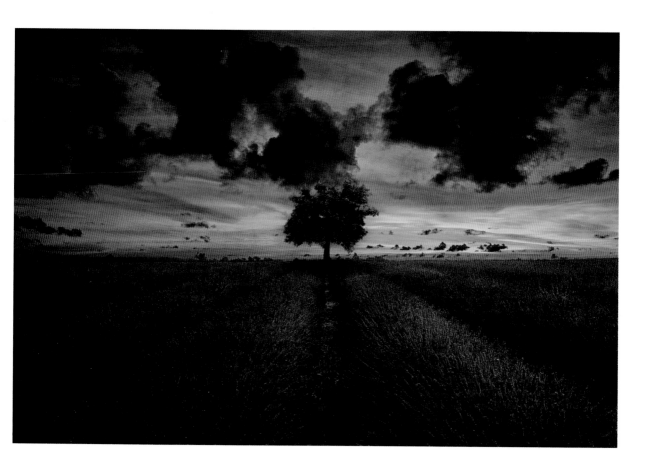

Making connections
How does it all fit together?

As a photographer you choose what you want to photograph and how you decide to show it to your audience, but how you *connect* with your subject—whatever it may be—will also show in your photographs. Creativity, interest, and intrigue are all factors that can make your images unique, and as no one sees the world in exactly the same way as you do, each of these elements will manifest itself in *your* photographs.

However, how you communicate your feelings toward your subject is a key aspect to creating compelling photographs. If they are to connect with your audience, you will want to try to make images that go beyond just documenting what you see. You want to show an association between your image and your subject. If you are taking a photograph of a person then you want to try to reveal more than just what they look like—you should try to convey a little more of who they are. Stopping to talk and engage before you take any shots can help in many ways. While you may find this hard at first, if you can overcome any shyness you will often be rewarded as barriers fall away.

When photographing your subjects, try to think about what you like about them, why you are photographing them, what you are thinking about, and what your viewers might think about them as well. The more photographs you take, the more experience and confidence you will gain in controlling your camera. This will help to free up your mind to concentrate on creating captivating and fascinating images that show your unique vision and connection with any subject you choose to photograph.

Why this photo works
THE SUGAR FARMER

When photographing people, the way that you choose to communicate and interact with them will have a direct impact on the images you are able to make. Approaching in a friendly way and simply asking will usually be met with a smile and approval; respecting personal space and a little basic courtesy will go a long way. This photograph of an elderly sugar cane farmer is a good example of a situation where making a connection was important. Although we didn't speak the same language, I was able to communicate with smiles, nods, and a knowing glance. I eventually pointed to the camera and he gave me a "thumbs up," happy to pose for this portrait in front of his home. If I had just snapped him from a distance the image wouldn't have had the same connection and intimacy.

Everything else you need to know
Telling your story **106–107**
Backgrounds **118–119**

Anticipating the moment
Good things come to those who wait

To create a strong and compelling photograph that is unique and captivating, you have to wait for the right moment to open the shutter. Once you have set up your composition and decided on which lens to use, the exposure, white balance, and so on, it can be useful to slow down and look around for anything that might change in the scene or might come into view and improve (or ruin) your final shot.

Some things can be quite obvious and straightforward, such as seeing clouds moving in a certain direction and waiting for the wind to blow them into the most visually appealing position, or waiting for people to enter or leave the frame, but other things will be more subtle. In either case, try to take some extra time to look around and don't rush your shot. Unless the scene is changing quickly, take a breath and wait to see what lies around the corner, as often things or people appear that can dramatically alter your original idea.

Being set up ready to capture your image can give you the necessary flexibility to wait and look and capture the fleeting moments that can help take your shot to the next level.

Why this photo works
WOMAN ON THE STAIRS

When I set up this composition I took particular care with the framing of the scene, taking my time to ensure that the lines were perfectly straight. But while I liked the image and found the lines and shapes visually interesting, I felt that it was lacking focal interest. There were quite a lot of people passing by and I decided to wait for someone interesting to include as they went up the stairs. I saw this particular lady and waited for her to walk into position before taking a burst of images. Anticipation and timing were key here: I needed to look ahead for suitable subjects and be ready to capture them as they passed by.

Everything else you need to know
Balance & visual weight **20–21**
Backgrounds **118–119**

Staying on the move
Everything comes to those who seek

All too often you see photographers turn up at an interesting landmark or beautiful rolling vista, put their camera to their eye straight away, take a shot, and then just walk away. But imagine the possibilities when you stop and look around! Don't take your camera out straight away. Instead, soak up what is around you, slow down, and take a moment to breathe. Think about where you are and what you can see. No doubt it took some time and effort to get here, so don't rush into snapping away. Wander around and get a feel for your surroundings. What is the view like over there? If you take a few steps to your left or right, how does that change the composition?

Having the opportunity to explore your scene can reveal an array of compositions that you may not have initially considered interesting. Unusual angles might present intriguing lines or, as you move around, the light and shadow might change and place emphasis on another aspect of your subject. A switch of position may alter shapes, and as perspective changes more may be revealed of your subject and how it relates to its background.

If you have more than one lens with you, consider changing lenses to provide further creative opportunities. You don't have to move far with a wideangle lens to make a radical compositional change or aim a telephoto in a slightly different direction to create a whole new shot.

Why this photo works
NYC IN THE SNOW

The snow was falling in New York City and I wanted to capture the feeling of the cold winter in the city streets. I spent time walking around trying to find interesting compositions and trying different angles and viewpoints. I came across this intersection and liked how the long avenue faded off into the distance with the falling snow. Although I tried a few shots from various positions, when the two taxis stopped at the traffic signal I saw another interesting composition. I safely positioned myself behind them and waited to include a taxi in the cross-traffic and the pedestrian, which add extra layers of interest to the image. Moving around and testing various compositions gave me a variety of images to choose my favorite from.

Everything else you need to know
Angle of view **22–23**
Backgrounds **118–119**

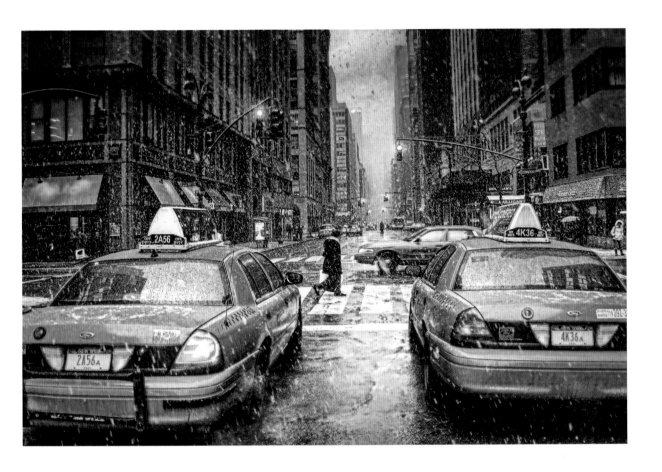

Backgrounds
Everything in the composition counts

The backgrounds in your images are important. They are often overlooked as something going on behind the object or person you are photographing, but choosing the right background can really help engage the viewer to look longer at your photograph—not just at the subject, but at the image as a whole.

The background is a key element that can make or break an image. The subject often needs to stand out to get the viewer's attention and to make it clear that it is the main focal point of the photograph. It can be extremely confusing if it is competing with a busy, distracting background, and this can result in a mess of ideas with the viewer not knowing where to look.

Using a wide aperture to throw the background out of focus is a great way of dealing with any distractions, but before you do, ask yourself whether including background detail adds to the context of the image. Does it help show the viewer where the subject is and give a sense of place or time? You have to decide!

In either case, it is important to scan the background for any distracting elements that could (and should) be removed, such as a streetlight or tree directly behind a person that might be poking out from above their head or a trash can that looks out of place. Run your eyes around the edges of the viewfinder as well, to check for anything unwanted creeping into shot. Tree branches are often overlooked, but it usually only takes a few steps to one side to refine the composition and remove unwanted objects or distracting elements from the frame.

Why this photo works
FARMING WITH OXEN

The background is a vital part of an image and choosing one that complements your subject will really improve the viewing experience. Here, the tropical location for this photograph is revealed by the palm trees and early morning mist in the background. I positioned myself so the trees were slightly to the side of the farmer and oxen, rather than directly behind them, as this would have led to a more cluttered and confusing image. I also waited for them to pass by the patch of sunshine, as that would have affected the exposure. The key is not to concentrate solely on the subject, but to check what's happening around them and behind them before you fire the shutter.

Everything else you need to know
Angle of view **22–23**
Shallow depth of field **46–47**

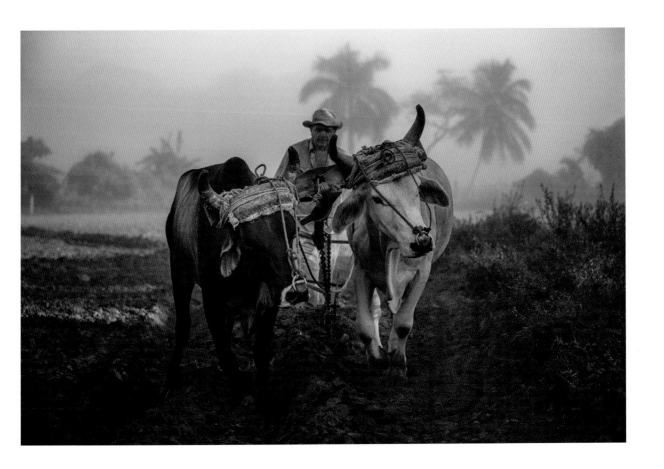

Focus
Everything we choose to reveal

Focus is critical in photography. Our eyes are fantastic at determining what we are looking at and ensuring that we can see it all very clearly, but as photographers we need to decide what the viewer looks at and how they see the photograph. This is determined in part by what we choose to reveal in sharp focus and what we render blurred.

Getting your images in sharp focus can initially cause a lot of problems. Your camera's autofocus (AF) will usually do a pretty good job when there is reasonably bright light or a contrasty subject, and most cameras will have a variety of focus points that you can select to help you; try to position one of these on the specific area of the image that you want in sharp focus, such as your subject's eyes in a portrait. It's really helpful to memorize how to select individual AF points without having to look away from the viewfinder to check your camera's controls.

Sometimes, though, you will find that the autofocus moves back and forth and is unable to lock onto your subject. This is when you will find it much easier to use manual focus, which is usually activated by a switch on your lens. This will give you full control to ensure that the area you want is correctly focused, but try to be gentle with the focusing ring and go slightly beyond what you think is the point of focus before pulling back slightly, just to make sure you have set the optimum focus.

Alternatively, use your camera's LCD screen and live view mode, as it will let you zoom into the scene and make focusing manually even more accurate. This is particularly helpful in low-light situations and when the camera is on a tripod.

Why this photo works
LONDON SUNSET

There was not much available light when I was taking this shot and I found that the camera was struggling to get a lock using autofocus. As I had the camera on a tripod (so I could use a slow shutter speed), I selected manual focus and used the camera's live view mode. This let me see the scene on the back of the camera before taking the photograph, and by zooming in to 100% magnification I could ensure that the focus was extremely precise—more so than by trying to focus in the dark through the viewfinder.

Everything else you need to know
Aperture **44–45**
Low-light photography **76–77**

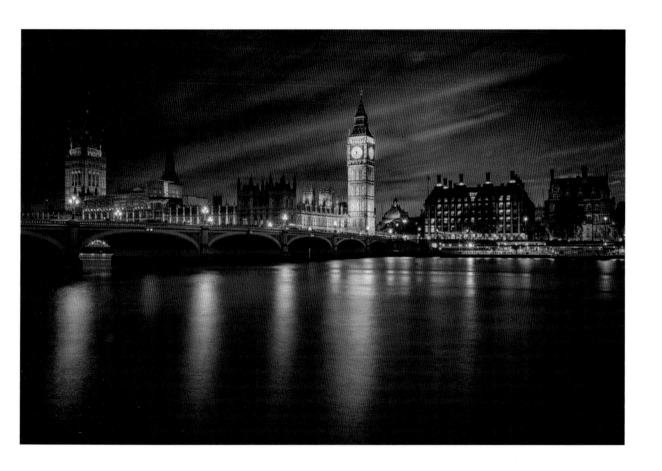

Troubleshooting

MY PHOTOS ARE BLURRED
Most blurred images are caused by camera shake, which is accidental movement of the camera while the shutter is open and an exposure is being made. Try using a faster shutter speed (increasing the ISO if necessary), activate any lens-based or in-camera image stabilization, and put the camera on a tripod or other stable surface to minimize any unnecessary movement.

MY COLORS DON'T LOOK RIGHT
This is most likely due to the white balance setting. Different light sources produce different colored light; for neutral results you need to make sure your camera's white balance setting matches the light source. Check out pages 80–81 for more information.

MY IMAGES LOOK GRAINY
Digital noise can affect your image when you are using a high ISO setting or a long exposure time. Noise usually appears in the darker shadow areas as colored blotches and a "gritty" texture. Try to reduce the ISO or use a faster shutter speed (depending on which of them is causing the noise) and see if you can still achieve the correct exposure. If not, the image-editing software on your computer may have noise reduction tools that you can use to minimize the appearance of noise in postproduction.

MY PHOTOGRAPHS ARE TOO BRIGHT OR TOO DARK
This is usually caused by an incorrect exposure setting, so check the aperture, shutter speed, and ISO, as well as your exposure compensation function (it may still be activated from a previous shot). If these are set correctly, it could be that an overly dark or overly bright subject is "fooling" the camera: dial in a small amount of negative exposure compensation to counter a bright exposure, or positive exposure compensation to deal with dark shots (see pages 66–67 for details).

DO I HAVE TO USE MANUAL MODE?

Definitely not! If you want to control your aperture (and depth of field), then shoot in Aperture Priority mode; if you want to control the shutter speed, use Shutter Priority mode. In both cases you can also set the ISO and override the exposure using exposure compensation. Manual mode is best when you want to control both the shutter speed *and* the aperture; where the light is constantly changing and you want to be able to change your settings to compensate; or when you want to maintain the same exposure across a sequence of shots.

MY SUNSETS LOOK WASHED OUT

This is typically due to a combination of things. The first is your white balance setting. If the camera's white balance is set to Auto it will try to neutralize the colors of a sunset, so switch to the camera's Daylight white balance setting, or use the Shade setting for added drama. The second problem is that your camera may be overexposing the sunset due to the low light levels. Dial in a small amount of negative exposure compensation to darken the image and saturate the colors a little more.

RAW OR JPEG?

A Raw file contains all the information that your camera captures, with no image processing taking place in the camera. This means images lack contrast out of the camera and will appear quite "flat"—they require you to process them on your computer. The advantage is that a Raw file has a wider dynamic range and can be processed without affecting the quality of the original file. A JPEG file is processed in-camera, so color, contrast, sharpness, and other characteristics are "baked in" when the file is saved and are harder to change. A JPEG is fine if you want small files that are quick to send and store and/or you do not want to spend time editing them later.

Glossary

ABSTRACT
An image where the subject is ambiguous and not easily identifiable.

APERTURE
The opening in the lens that controls the amount of light that can pass through to the sensor.

APERTURE PRIORITY
Exposure mode where the photographer chooses the aperture and ISO, and the camera calculates the shutter speed.

BULB (B)
Exposure mode that allows the camera's shutter to be held open manually for an indefinite amount of time. Typically used for exposure times longer than 30 sec.

CAMERA SHAKE
Image defect caused when the camera is moved unintentionally during an exposure, resulting in a blurred image.

CENTER-WEIGHTED METERING
An exposure metering mode that sets the exposure with a bias toward the center of the frame.

COLOR TEMPERATURE
The color of a light source, as measured in degrees Kelvin (K).

CONTINUOUS MODE
A shooting mode that lets the camera take multiple exposures in rapid succession for as long as the shutter-release button is held down, or until the camera's built-in image buffer is filled.

CONTRAST
The range of tones in an image from the lightest to the darkest.

DEPTH OF FIELD
The zone of apparent sharpness in an image, which extends either side of the point of focus.

DYNAMIC RANGE
The range (usually given in stops) between the brightest highlight and darkest shadow in a scene or image.

EXPOSURE
The level of light that the camera records in a scene to create the image.

EXPOSURE BRACKETING
The process of taking a number of images of the same subject at different exposure values, either to ensure that one exposure is "correct," or with a view to combining the sequence in postproduction to create a single image with a wide dynamic range.

EXPOSURE COMPENSATION
A camera feature that adjusts the brightness of the image, overriding the camera's exposure metering.

F-STOP
The measurement used to indicate the size of the aperture.

FILE FORMAT
The way that a digital image is recorded: common formats for photography include JPEG, TIFF, DNG, and a range of proprietary Raw formats.

FILTER
A piece of glass or resin that attaches in front of the lens to modify the light.

FOCAL LENGTH
The distance from the optical center of a lens to the focal plane (sensor), measured in millimeters (mm).

HISTOGRAM
A graphic representation of the range of tones in a scene or image.

IMAGE STABILIZATION
Lens-based or in-camera technology that assists in reducing camera shake.

ISO
A digital control of the sensitivity of the camera's sensor to light.

MANUAL MODE
Exposure mode where the aperture, shutter speed, and ISO are all set by the photographer.

METADATA
Exposure and other image data recorded alongside the image itself.

MONOCHROME
An image without color.

MULTI-AREA METERING
A metering mode where the camera measures a number of points in the scene to determine the correct exposure.

NOISE
Random pixels that appear in an image when a high ISO setting or long exposure time is used. Noise usually presents itself in the shadow areas.

OVEREXPOSURE
Where the captured image is too bright and detail is lost in the highlight areas.

PRIME LENS
A lens with a fixed focal length.

REMOTE RELEASE
An external shutter control that can trigger the camera through a wire (or wirelessly) to minimize camera shake. Also used with Bulb mode.

SENSOR
The imaging chip in a digital camera that records all of the image data.

SHUTTER PRIORITY
Exposure mode where the photographer chooses the shutter speed and ISO and the camera calculates the aperture.

SPOT METERING
Exposure metering mode where the camera uses a very small area at the center of the frame or at the focus point to determine the exposure reading.

TELEPHOTO LENS
A lens with a long focal length that can capture objects far away and has a narrow field of view.

UNDEREXPOSURE
Where the captured image is too dark and detail is lost in the shadow areas.

WHITE BALANCE
A camera control used to set the color temperature of the light source and avoid any color casts.

WIDEANGLE LENS
A lens with a short focal length that can capture a wide field of view.

ZOOM LENS
A lens covering a range of focal lengths.

Index

First published 2019 by
Ammonite Press
an imprint of Guild of Master Craftsman Publications Ltd
Castle Place, 166 High Street, Lewes, East Sussex, BN7 1XU, United Kingdom

ISBN: 978-1-78145-377-3

Publisher: Jason Hook
Design Manager: Robin Shields
Editor: Chris Gatcum
Designer: Michael Whitehead

Color reproduction by GMC Reprographics
Printed and bound in China

AUTHOR ACKNOWLEDGMENTS
Once again, I am grateful for the opportunity to make this book and so wish to thank Jason,
Robin, Chris, and all of the lovely folks at Ammonite Press. Thanks to my family, just as
important as ever, for your limitless love and support. Thanks to my excellent model Meghan,
and finally to Shauneen too for her unwavering ability to listen to me and her endlessly
insightful thoughts! Another journey begins...

AMMONITE
PRESS

www.ammonitepress.com

How was the book?
Please post your feedback and photos
#EYAWTKA